KILMARNOCK

THE POSTCARD COLLECTION

FRANK BEATTIE

AMBERLEY

ABOUT THE AUTHOR

Frank Beattie is well known in his home town of Kilmarnock, mostly through his work for the *Kilmarnock Standard*. He has written several books covering different aspects of the history of Kilmarnock. Since taking early retirement, he has written three short novels and has become involved in various local projects including the revamp of the railway station underpass, the innovative memory game for the local Alzheimer group and the annual Kilmarnock Halloween Festival. He continues to write a weekly page on local history matters for the *Kilmarnock Standard*.

I HAVE JUST ARRIVED AT KILMARNOCK

First published 2017

Amberley Publishing
The Hill, Stroud, Gloucestershire, GL5 4EP
www.amberley-books.com

Copyright © Frank Beattie, 2017

The right of Frank Beattie to be identified as the
Author of this work has been asserted in accordance with
the Copyrights, Designs and Patents Act 1988.

ISBN 978 1 4456 7034 8 (print)
ISBN 978 1 4456 7035 5 (ebook)

British Library Cataloguing in Publication Data.
A catalogue record for this book is available from the British Library.

Origination by Amberley Publishing.
Printed in Great Britain.

CONTENTS

INTRODUCTION

When we think of postcards we tend to think of greetings from seaside towns. Kilmarnock is an inland industrial town and not the type of place you might expect to produce hundreds of postcards.

But in the early twentieth century people used postcards rather like we use text messages today. So postcards exist of Kilmarnock's streets, parks, mansions and factories.

No one can be sure when Kilmarnock was founded. The name is a dedication to St Mhearnog, or Marnock in modern English. But did the community grow around a remote church or was a church attracted to a remote community?

The town's emblem is based on the coat of arms of the Boyd family, who were the major landowners in the area. Their motto, Goldberry, was adopted after the Battle of Largs of 1263, which saw an end to Norse interests in the Scottish islands. The name lives on today in a long-established local pub.

Growth was slow. Sometime between 1609 and 1612, topographer Timothy Pont visited Kilmarnock and described it as a large village.

Towards the end of the 1700s everything changed because of coal, which was being exported to Ireland through the port at Irvine. It was taken there by packhorses. There had to be a better way. Then a new landowner, the Marquis of Titchfield, came on the scene. He owned the Kilmarnock mines and land at Troon, where he built a harbour. He had a railway built – the first in Scotland constructed under the authority of Parliament. It carried passengers from June 1812 and unsuccessfully tried steam power in 1816.

Trains took coal to Troon and came back with building materials and other goods. Kilmarnock started to boom. The railway ultimately gave birth to engineering companies such as Barclays, and others such as Glenfield soon followed.

Railways helped local companies send goods all over the country and beyond. Leather and tanning grew into boot and shoemaking, which eventually saw the creation of Saxone. Weaving led to carpet making, which led to the formation of BMK. Brick making led to a huge industry making not just bricks but sanitary goods and even stone lions. Kilmarnock's most famous product, Johnnie Walker whisky, emerged as the world's first global brand.

In the middle of the twentieth century Kilmarnock's base of skilled engineers attracted other companies such as Massey Ferguson and Glacier Metal. A special Kilmarnock Technical School was built. In the 1960s, Kilmarnock was booming, had full employment and a very successful football team.

Then circumstances started to conspire against Kilmarnock. Globalisation saw cheap imports. UK companies found it hard to compete. Large nationalised enterprises were closed. Coal mines closed and prosperity was replaced with nothing but poverty and despair.

But now things have turned around. Over the last few years massive efforts by community groups, the local council and the Scottish government have come together. Kilmarnock is now home to the Ayrshire Athletics Arena, a top-rated venue and one of only a few in the country built to Olympic standard.

Long-neglected buildings and public open spaces have been transformed by a combination of community effort and political will. There has been massive investment in building new private and social houses. In 2015, Kilmarnock was declared Scotland's most improved large town. Health and education are investment priorities and old schools are being replaced.

In December 2016, First Minister Nicola Sturgeon officially opened the state-of-the-art £53 million Kilmarnock campus of the Ayrshire College.

The same month saw the transformation of the town's long-neglected railway underpass from a dismal forbidding passage into a bright celebration of the town's history and heritage.

Kilmarnock is finding its way again. Many other improvements are underway or planned, from a business enterprise hub, new schools and more houses to additional community art projects.

No doubt some of them will find their way onto new postcards.

SECTION 1
AROUND TOWN

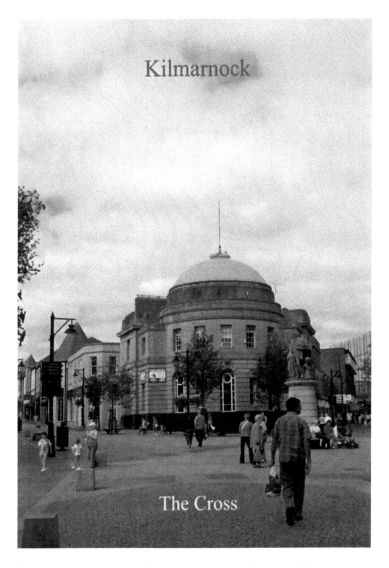

The Cross as it is today. (Picture courtesy of Kev's Cards)

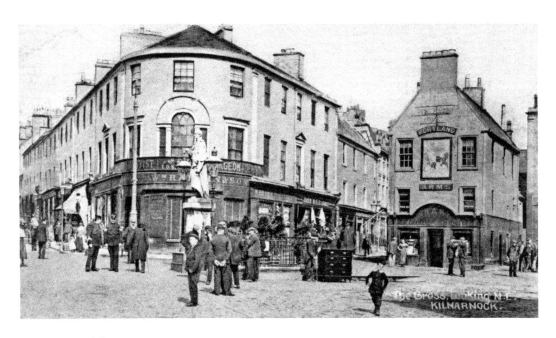

Heart of the Town

The Cross is the commercial centre of Kilmarnock. It has been altered many times since it was first used as a market in 1609. A tollbooth was built there in the 1690s and the town's corn mill was there until 1703. In the eighteenth century the Cross was hemmed in, but King Street was opened up in 1804 and Portland Street was built soon after. Today the statues of Robert Burns and John Wilson watch over the town.

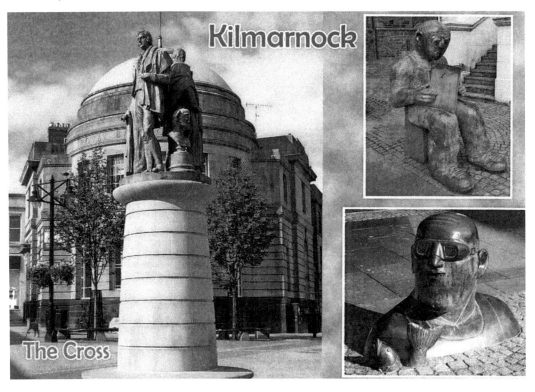

Kilmarnock

The Cross

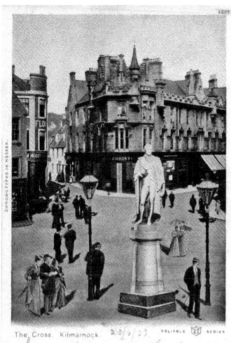

The Cross. Kilmarnock. 2/6/03. RELIABLE SERIES

I am perhaps not on the close proof but I am here sure enough arrived early this forenoon. John

Man of the People

James Shaw was born at Riccarton in 1764. In 1781, he left for America but returned a few years later. Then he headed for London where he quickly rose through the ranks of society. He became an MP and Lord Mayor of the city. He was Lord Mayor of London at the time of Lord Nelson's funeral and he accompanied the king in leading the mourners. He always supported good causes in his home town. A statue to him was placed at the Cross in 1848 but today it is in London Road.

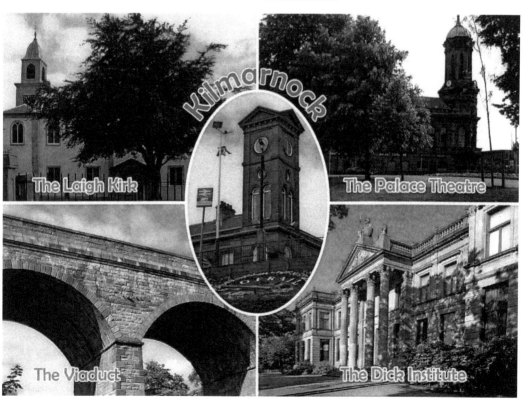

Kilmarnock

The Laigh Kirk

The Palace Theatre

The Viaduct

The Dick Institute

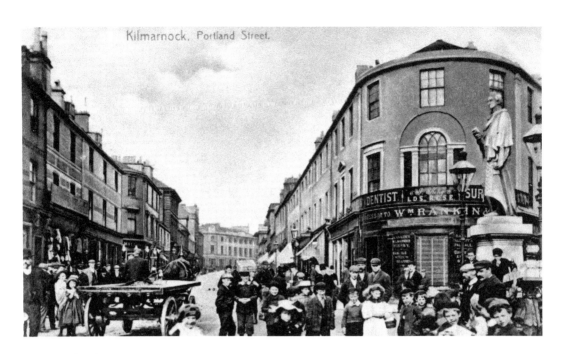

Kilmarnock, Portland Street.

Portland Street

Portland Street was opened up from the Cross and developed in the first two decades of the nineteenth century, essentially as an extension of King Street. Wellington Street and Dean Street were added, opening up the land to the north of the town. Portland Street quickly became one of the main commercial streets of the town. The building now used as Mason Murphy's furniture shop was the George Hotel and it was built on or near the site of Sandy Patrick's pub, which was often frequented by Robert Burns. Here, too, was the original site for the Kilmarnock Bowling Club, which was established in 1740.

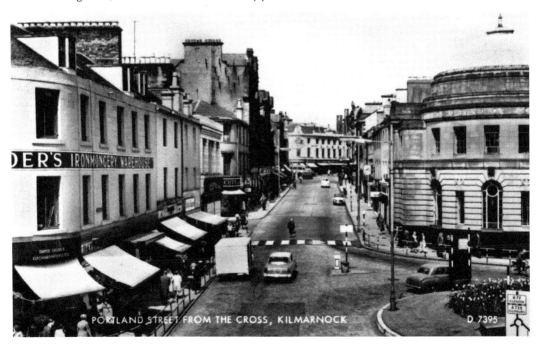

PORTLAND STREET FROM THE CROSS, KILMARNOCK D 7395

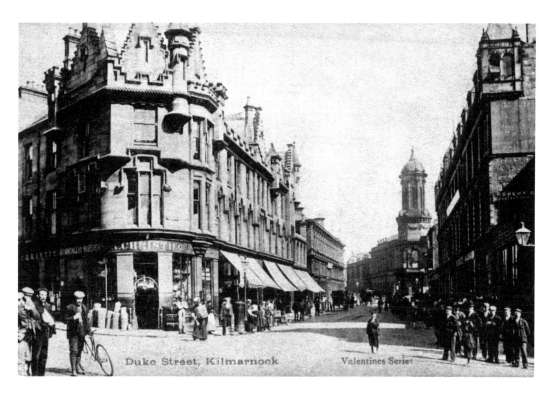

Duke Street, Kilmarnock Valentines Series

Street of Fairy Castles

Duke Street was opened as the entrance to the town from the east, linking the Cross to London Road. It was opened in 1859, but during construction it was called Victoria Street. It consisted of fine architecture that many children thought of as fairy castles. The street was demolished in 1973 to make way for the Burns shopping mall.

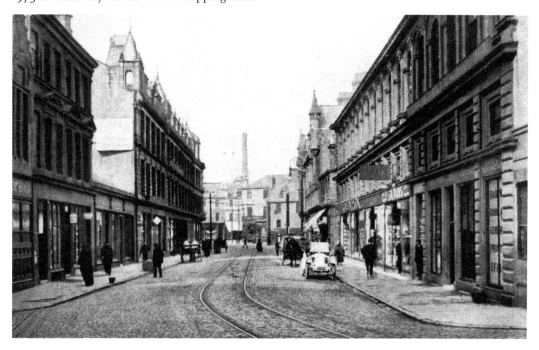

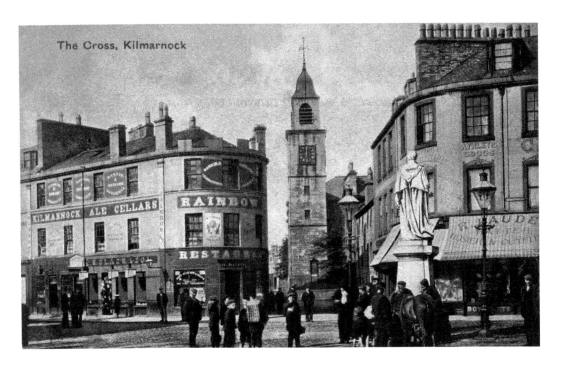

The Cross, Kilmarnock

Cheapside and Bank Street

The line of Cheapside, or Cheapside Street, was opened up around 1550 or before and was probably used by the market traders. It led to the parish church. It is seen here in an artificially coloured postcard of around 1900. Just beyond Cheapside there is Bank Street, which was created in 1710. It had previously been part of the graveyard of the kirk. The sloping ground down to the Kilmarnock Water was built up to make it level before houses and shops were built on it.

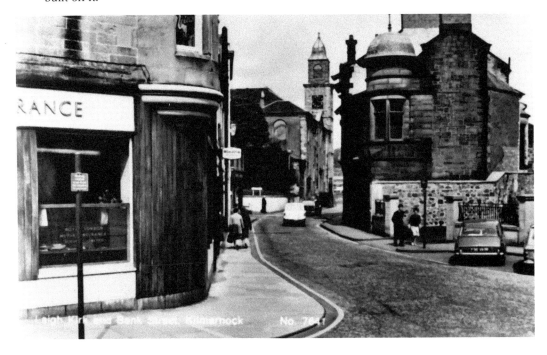

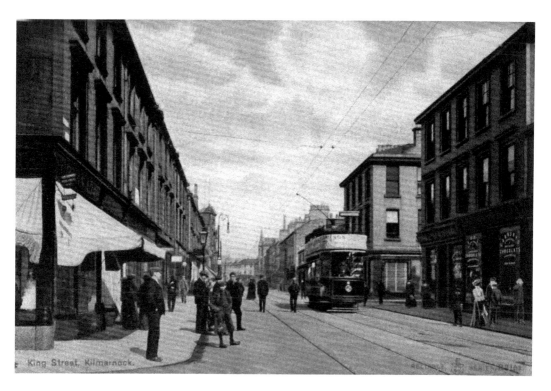

King Street, Kilmarnock.

King of Streets

Before King Street was opened up in 1804 the centre of Kilmarnock consisted of many narrow and crooked lanes. They were swept away to create a wide straight road, which quickly became the main street in the town. In the twentieth century traffic management was the challenge as trams were replaced with private cars.

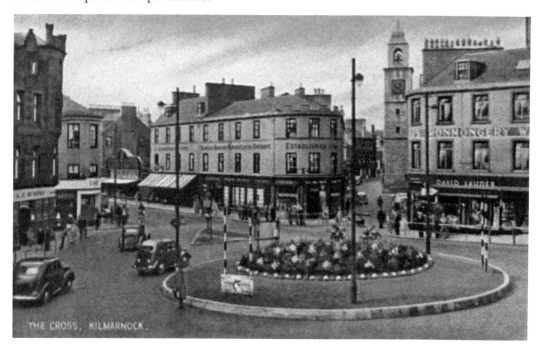

THE CROSS, KILMARNOCK.

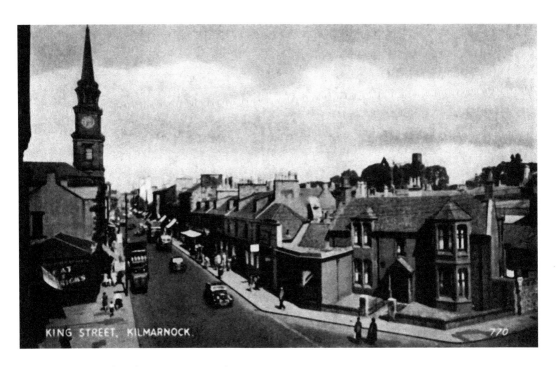

Commercial and Community Hub

King Street attracted businesses, residents and other groups. The picture above shows King Street Church, which was built in 1832 on the corner of King Street and Saint Marnock Street and was demolished in 1966 to make way for a row of shops. The building on the right was a doctor's home and surgery. By the 1960s many of the shops in King Street were national retailers such as Boots, Marks & Spencer and Woolworths.

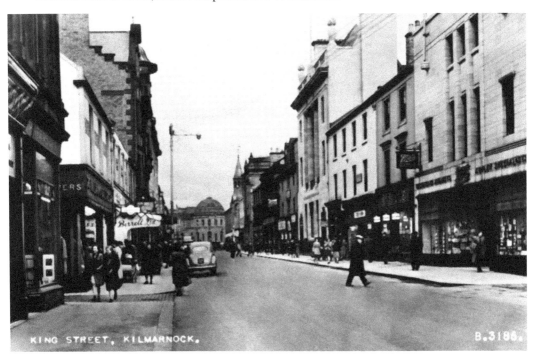

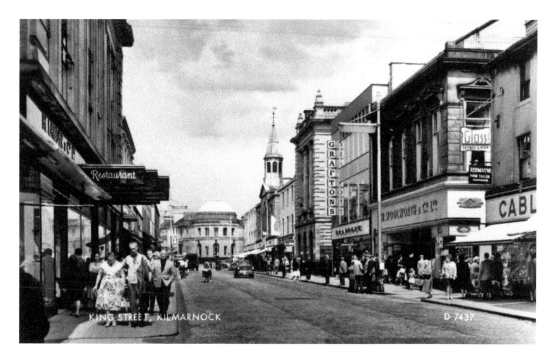

Times Change

The picture above of King Street was taken in 1962, but things were about to change. By the start of the 1970s all the buildings on the right side, with the exception of the Graftons building, were swept away and replaced with a shopping centre with all the architectural merit of a shoebox. Below is a more recent view of Christmas shoppers at the Cross.

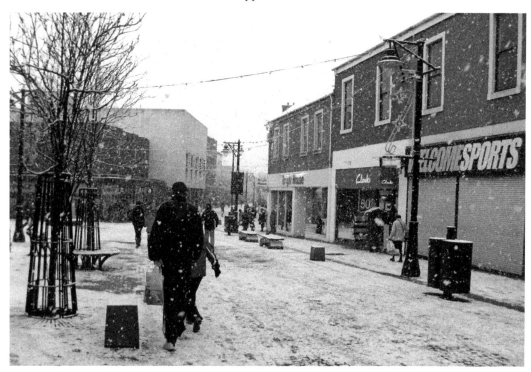

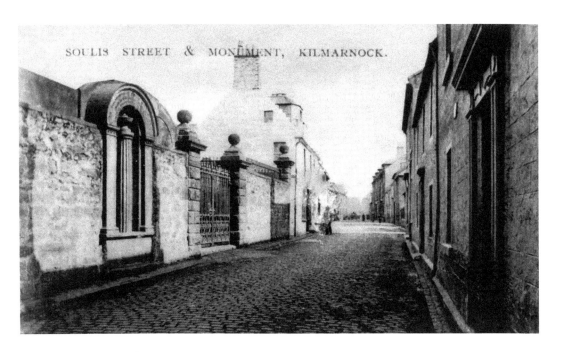

SOULIS STREET & MONUMENT, KILMARNOCK.

A One-time Highway

Until the start of the nineteenth century the main road out of Kilmarnock towards Glasgow was by Fore Street, Soulis Street and High Street. Soulis Street is named after a Lord Soulis, an enigmatic figure thought to have lived in the fourteenth century. There is still a monument to him here. Beyond Soulis Street there was the High Street. As the name suggests, it was once the most important street in the town. Even in the middle of the eighteenth century it was one of the preferred streets for the homes of the merchants.

HIGH ST. KILMARNOCK.

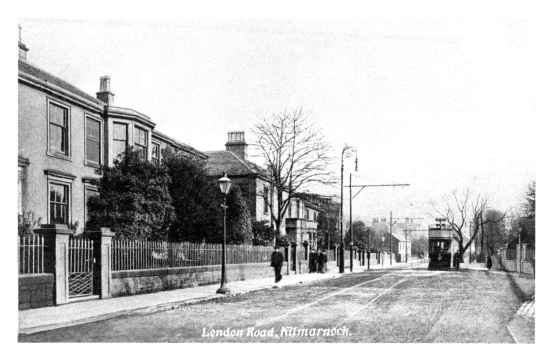

London Road

London Road runs from the town centre almost to Crookedholm and contains many fine villas, several of which are now listed buildings. Among the important buildings in London Road there is the Palace Theatre, Grand Hall, Kay Park Parish Church and Tankerha. In 1837, unemployed men were hired to cut out the hill between Braehead House and Rosebank, the home of Tam Samson, a local businessman who was a friend of poet Robert Burns.

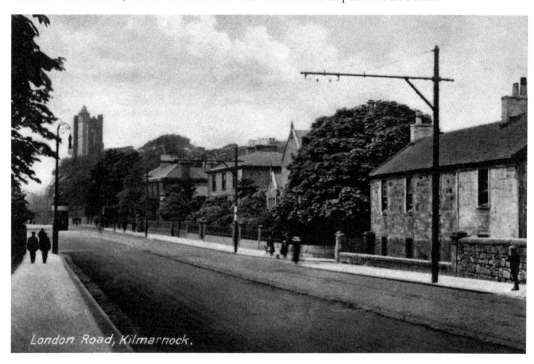

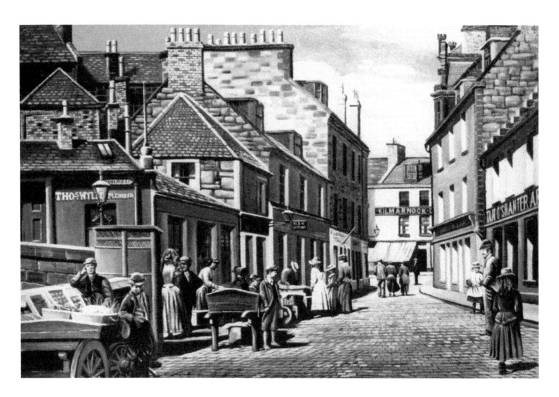

Town Centre Streets

Waterloo Street was a narrow lane until it was reshaped into a street in 1752 as Greenfoot. It was renamed to commemorate the many local men who fought in the Battle of Waterloo in 1815. John Wilson established a printing press here and in 1786 printed the Kilmarnock edition of the poems of Robert Burns. Woodstock Street runs from John Finnie Street to Fullarton Street and includes the former Grange Church now being converted to a climbing adventure centre.

WOODSTOCK STREET, KILMARNOCK VALENTINES SERIES

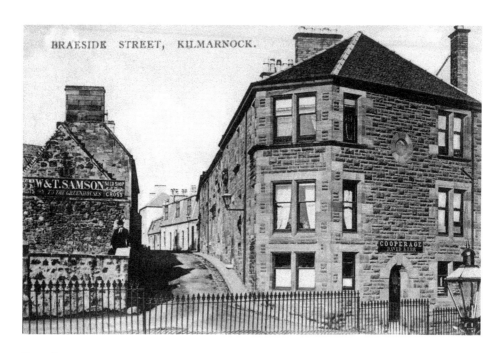

BRAESIDE STREET, KILMARNOCK.

Busy Streets

Braeside Street was built on part of the steep hill at London Road. It appears on a map of 1783 simply as Braeside and some of it still exists today. Dundonald Road was developed mostly in the nineteenth century when the town's population more than doubled. The first house was Wards House, built in 1828. At the corner of Dundonald Road and Portland Road is Holy Trinity Church, which has a garden of remembrance containing an old milestone and, less obvious, the remnants of an old well. This area was once known as Winton Place.

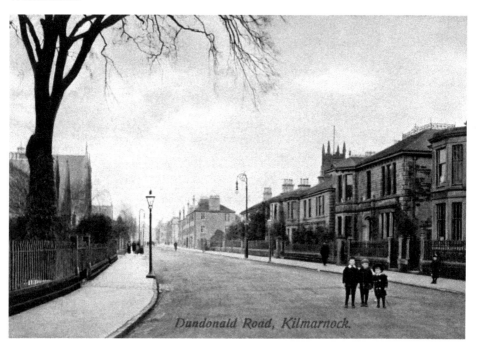

Dundonald Road, Kilmarnock.

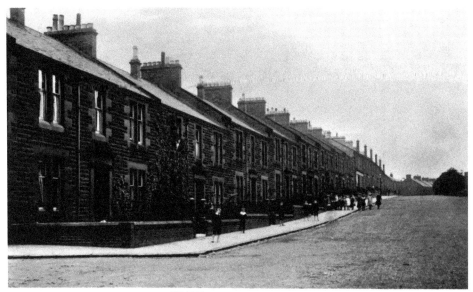

KILGOUR TERRACE . KILMARNOCK

Old War Remembered

Kilgour Terrace is part of Bonnyton Road. The houses were named after the wife of the builder, a D. Ramsay of Saint Andrew Street. On the opposite side of Munro Avenue the houses are known as Ava Terrace. The names are etched into the stonework. The origin is obscure. Ava was the ancient capital of the Burmese empire. Britain was involved in three wars there in the nineteenth century, so the name may relate to that.

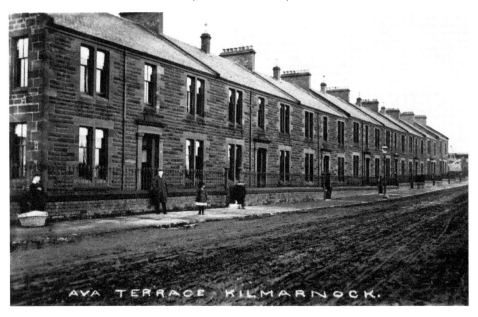

AVA TERRACE . KILMARNOCK.

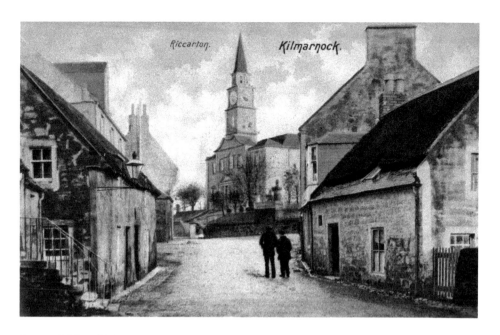

Streets Old and New

As the name implies, Old Street in Riccarton was one of the early streets in this area and it retained much of its character, such as thatched cottages, into the twentieth century. New Street in Riccarton was created out of Crompton Street in the middle of the nineteenth century.

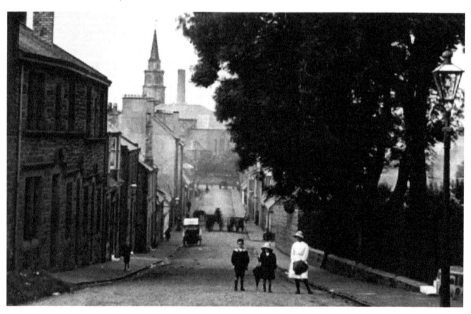

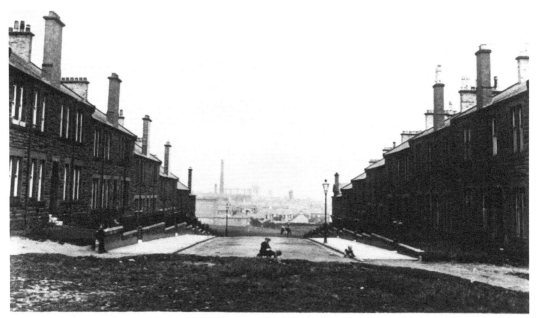

GIBSON STREET, KILMARNOCK

A Place to Live

As Kilmarnock expanded rapidly in the second half of the twentieth century many streets were opened up and tenement buildings constructed, often with four apartments. These streets included Gibson Street and Glebe Road. In many of these streets a corner house was converted to a small shop for local residents.

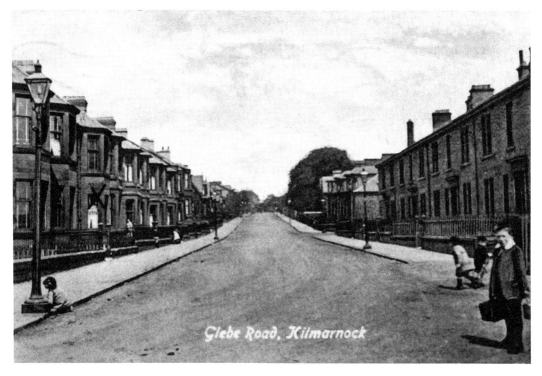

Glebe Road, Kilmarnock

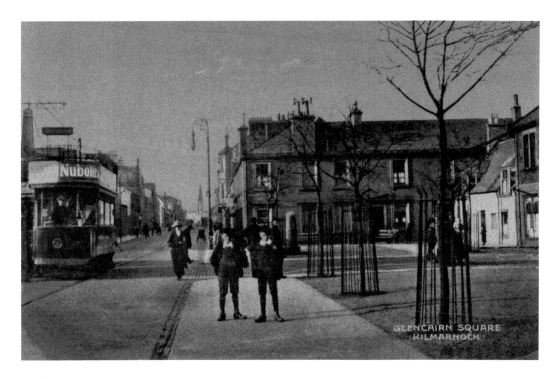

A Place to Meet

Glencairn Square was opened in 1765 and until the twentieth century was the Holm Square. In April 1800, fire swept through here, destroying houses and a school. It was at the Holm Square that workers often met and, reading from a shared newspaper, discussed the issues and their ambitions for a more just society. This was known as the Holm Parliament. Today, Glencairn Square is a busy intersection with a constant flow of traffic.

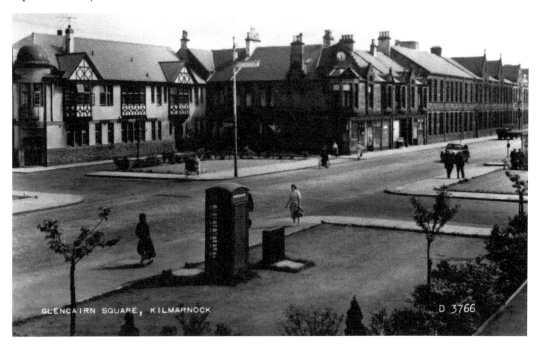

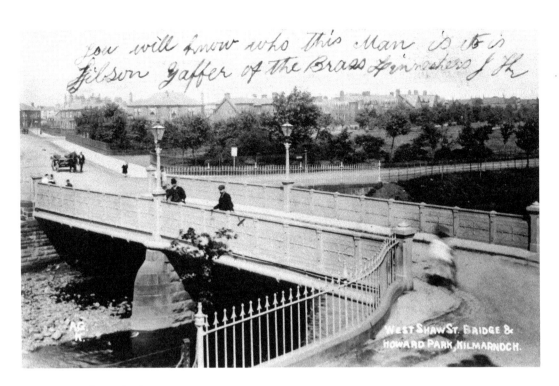

you will know who this Man is it is Gilson gaffer of the Brass finnishers J H

WEST SHAW St. BRIDGE & HOWARD PARK, KILMARNOCK.

Streets from the Square

Four streets run off Glencairn Square; East and West Shaw Street and Low and High Glencairn Street. The West Shaw Street Bridge over the Kilmarnock Water links West Shaw Street and McLelland Drive. It was built in 1888. High Glencairn Street was opened up in 1765 by the Earl of Glencairn as part of the main route between Kilmarnock and Riccarton.

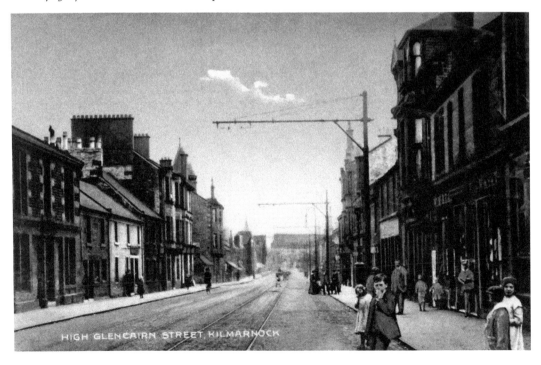

HIGH GLENCAIRN STREET KILMARNOCK

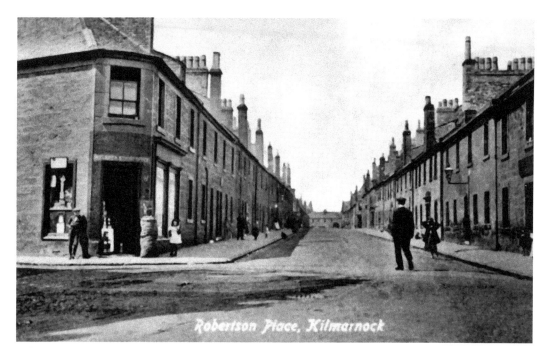

Robertson Place, Kilmarnock

Improving the Town

In 1824, the Kilmarnock Building Co. was formed. Members each paid an entry fee and a monthly subscription to allow the building of houses. The first street they built was Robertson Place. Titchfield Street was developed from the middle of the eighteenth century and linked King Street with High Glencairn Street on the route from the Cross to Riccarton, and from there on to Ayr. It replaced a straggling narrow route with a wide straight route. Part of the original road was Old Cast Lane.

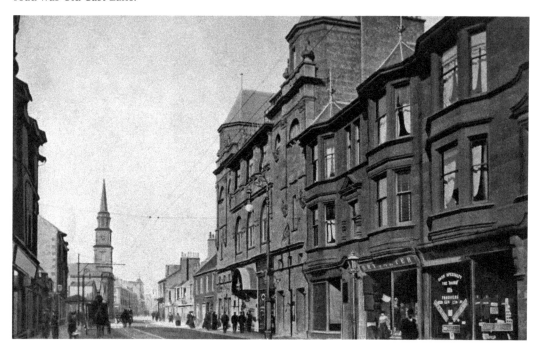

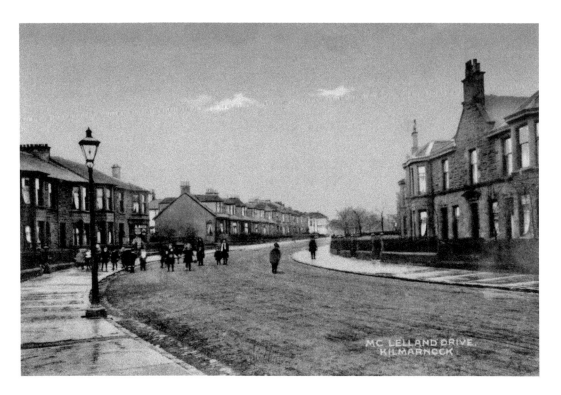

More Housing

McLelland Drive is named after Archibald McLelland, who was once the provost of Kilmarnock. There are many fine villas here. Charles Street is named after Charles Augustus, 2nd Baron Seaford and 6th Baron Howard de Walden, a local landowner. This street also contains some fine properties.

CHARLES STREET, KILMARNOCK.

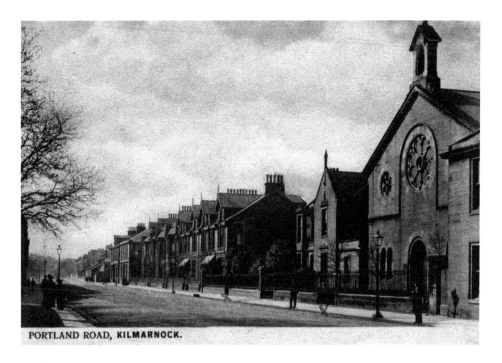

PORTLAND ROAD, KILMARNOCK.

Landowners

The influence of major landowners cannot be overstated. In the days before democratic influences it was often the local landlord who decided all matters. Portland Road was named after the Duke of Portland. This street extended the western extremity of the town beyond Saint Marnock Street. Portland Road has many fine buildings. It was not just major streets the landowners influenced. In 1813, the Craufurdland Bridge was built near Fenwick. The decorative stone balusters originally formed part of the battlements of Cessnock Castle.

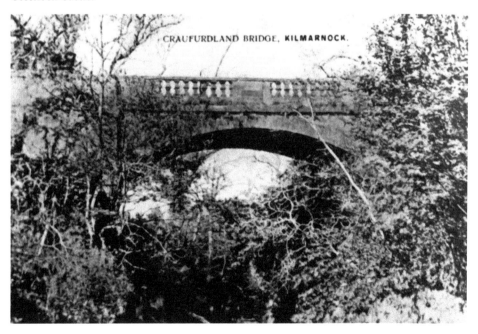

CRAUFURDLAND BRIDGE, KILMARNOCK.

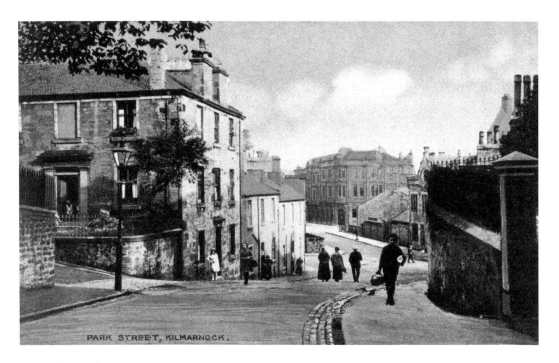

PARK STREET, KILMARNOCK.

Places of Interest

Park Street is just off John Finnie Street. Park Street and Park Lane seem to take their name from the Park family who once owned the nearby Langlands House. At one time Park Street was popularly known as the Gas Brae because the town's gasworks were here. Just off London Road there is what is popularly called the Sunken Garden. It is the site of a former house but today is a popular area for those wishing to take a break from the hustle and bustle of the town.

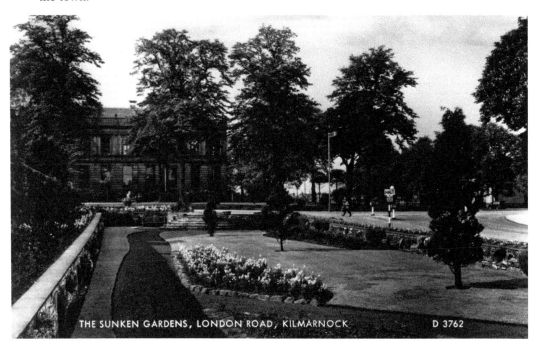

THE SUNKEN GARDENS, LONDON ROAD, KILMARNOCK D 3762

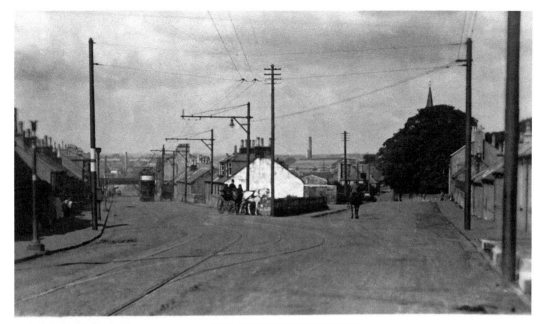

CAMPBELL STREET, RICCARTON

Streets of Contrast

Campbell Street forms part of the main route through Riccarton from Kilmarnock to the Ayr Road. It is named after the Campbell family of Loudoun. The town's fire station is here and there is a plaque marking the connection with the Wallace family of Riccarton, who did so much to ensure Scottish independence. South Hamilton Street is one of several streets opened up or expanded between 1851 and 1879. South Hamilton Place is a small area of houses off South Hamilton Street. The house on the corner between the two, on the left of the picture, was a nurses' home.

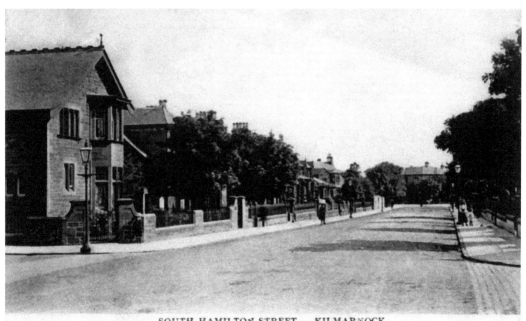

SOUTH HAMILTON STREET — KILMARNOCK

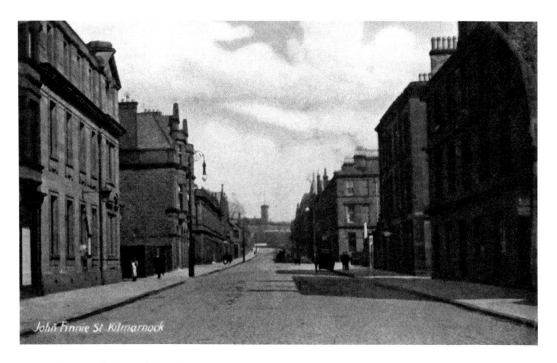

John Finnie Street Yesterday

John Finnie Street is one of the main thoroughfares in Kilmarnock and is an outstanding example of Victorian planning. When opened in 1864, this long and wide street cut across several narrow and crooked lanes such as Nelson Street and Dunlop Street. Nearly all the buildings are constructed of red stone and most are of fine architecture. William Railton was the architect responsible for the initial planning of the street.

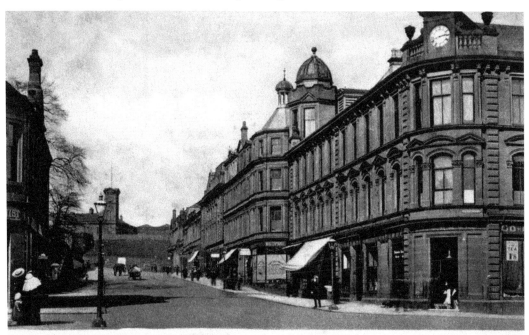

JOHN FINNIE STREET, KILMARNOCK.

John Finnie Street and Bank Street, Kilmarnock No. 7635

John Finnie Street Today

There is a constant roar of traffic in the John Finnie Street of today. It is a busy thoroughfare with the railway station at the top of the street. The town's first custom-built theatre, the grandly named Opera House, was opened in John Finnie Street in 1875. Later, the building had various uses, but in 1989 it was destroyed by fire, leaving only the façade. The site lay derelict until a new initiative on the site in 2012 saw the site redeveloped using the original façade.

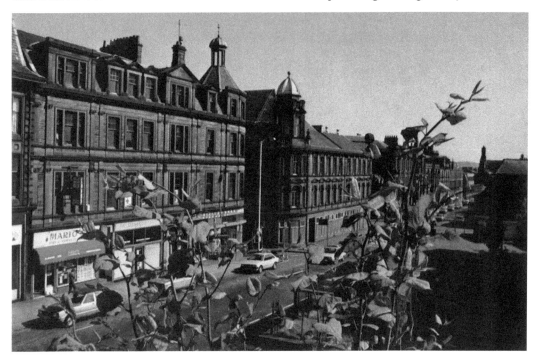

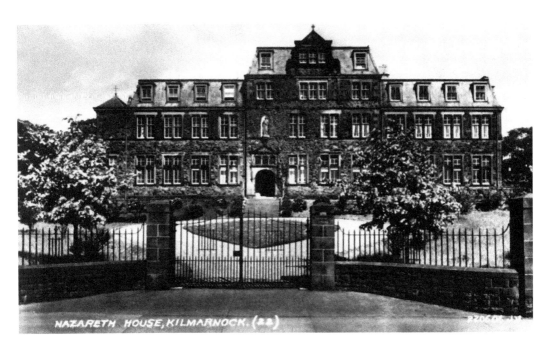

NAZARETH HOUSE, KILMARNOCK. (23)

Impressive Buildings

Nazareth House was built in Hill Street in 1890 as an orphanage and old folks' home. In its later years it was just an old folks' home run by the Sisters of Nazareth. It closed in 2002. Nazareth House was built on ground that had once been Hawket Park. Several local Masonic lodges opened their new purpose-built property at London Road on the former site of two houses in 1927. The architect was William Forrest Valentine.

Masonic Hall, Kilmarnock.

SECTION 2

BUILDING THE COMMUNITY

Riccarton more than 100 years ago.

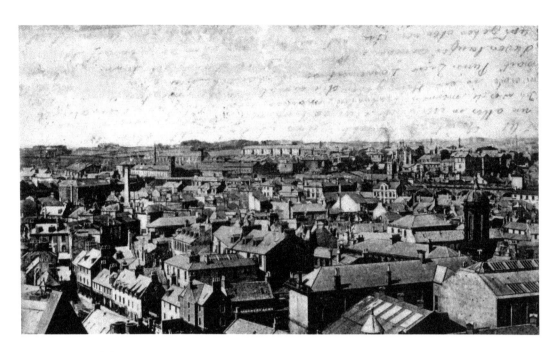

Town and Country

At the end of the nineteenth century and start of the twentieth century Kilmarnock town centre was crowded. Big housing areas such as Shortlees, Bellfield, New Farm Loch and others were still far off. Even the Dean Castle was on the fringe of the built-up area of the town.

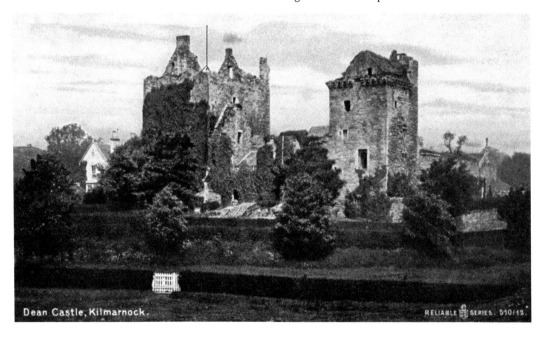

Dean Castle, Kilmarnock. RELIABLE SERIES. 510/12.

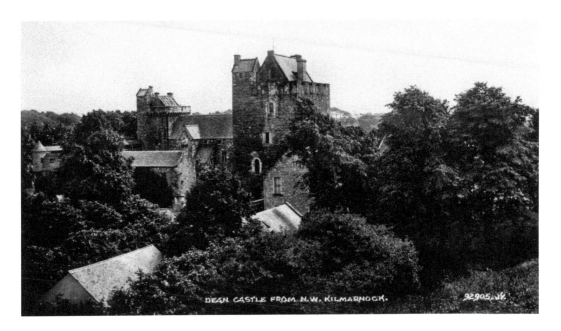

DEAN CASTLE FROM N.W. KILMARNOCK.

Dean Castle

History is vague on the origin of the Dean Castle, but it was the seat of the feudal lords of Kilmarnock. The most important were the Boyds. Robert Boyd fought at the Battle of Largs in 1263, and the Boyds later fought with Robert the Bruce in the war of independence. The castle was substantially damaged by a fire in 1735 and fell into ruin, but it was restored in 1930s and given to the town in 1975 along with its internationally important collections of arms and musical instruments. Dean Castle is now the area's top tourist attraction.

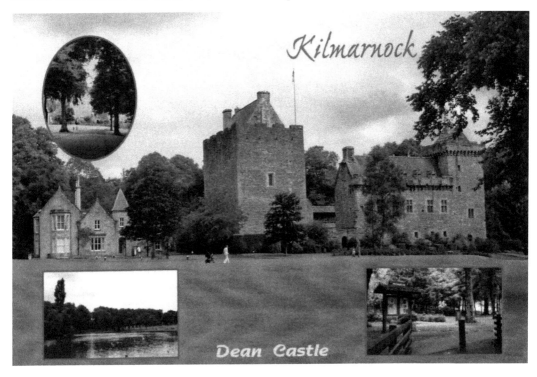

Kilmarnock

Dean Castle

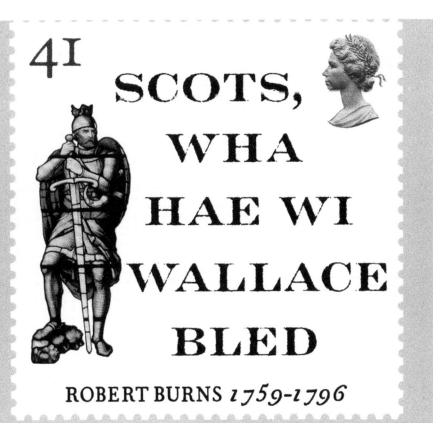

41 SCOTS, WHA HAE WI WALLACE BLED

ROBERT BURNS *1759-1796*

Scotland's National Bard
Robert Burns (1759–96) was never
the peasant farmer poet that some
romantic historians like to think.
He was given a sound education
and was equally literate in Scots
and English. Several of his poems
have a Kilmarnock setting; he had
many friends in Kilmarnock and
the first book of his poems was
printed by John Wilson (1759–1821)
of Kilmarnock. Wilson's typeface was
used on a UK commemorative stamp.
(Pictures courtesy of Royal Mail and
the National Trust for Scotland)

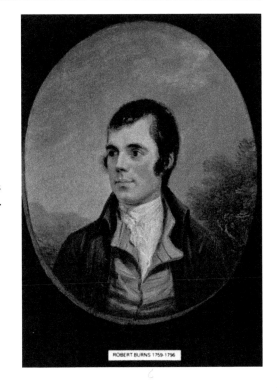

ROBERT BURNS 1759-1796

THE HOAX, THE HOAXER, AND THE HOAXED.

"JOY."

A Joke That Got Out of Hand

In 1904, a joke by a local councillor got completely out of hand. Bailie William Munro sent a fake letter to the town council saying that Andrew Carnegie would pay for a Burns Temple to be built in Kilmarnock. The temple was to be of granite or white marble and would contain statues of Burns' associates. The offer soon became national news. But there was no such offer. Eventually, Munro admitted his part in the affair and by way of apology presented Kilmarnock Infirmary with £50.

KILMARNOCK HOUSE.

Grand Mansions

Kilmarnock House was demolished in 1935. It had been the home of the Boyds of Dean Castle and later of the Earl of Glencairn. Later still it was an industrial school. Stone from Kilmarnock House was used in the restoration of Dean Castle. The site of the house was never redeveloped and is now a car park. For six centuries Loudoun Castle was home to the Campbell family and the mother of Scotland's hero, Sir William Wallace, was born here. As the family grew in importance the castle was extended. In later years it was known as the Windsor of the north. Loudoun Castle was destroyed by fire in 1941 and today only a shell of the once great building survives.

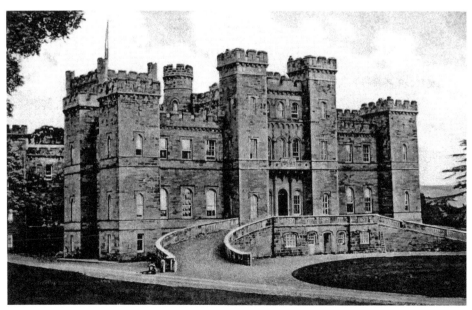

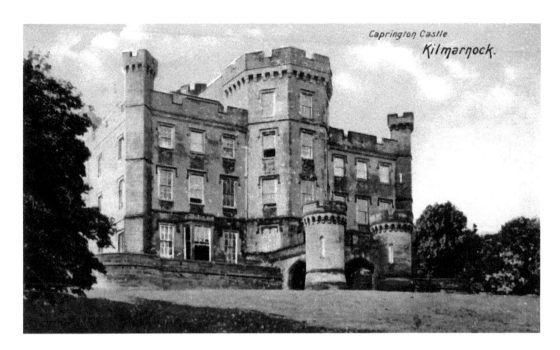

Caprington Castle
Kilmarnock.

Wallace Castles

Caprington Castle on the southern edge of Kilmarnock is mentioned in a charter dated 1385. At one time it belonged to the Wallace family but as early as 1462 it belonged to the Cunninghame family who still possess it today. Many alterations to the building have been made over the centuries and the façade of today dates from 1829. Craigie Castle was once the most magnificent castle in Ayrshire. It belonged to the Wallace family of Riccarton. They occupied it until they moved to Newton-upon-Ayr in 1588, leaving their once magnificent castle to fall into ruin. The Wallace's were a very powerful family and some had distinguished military careers.

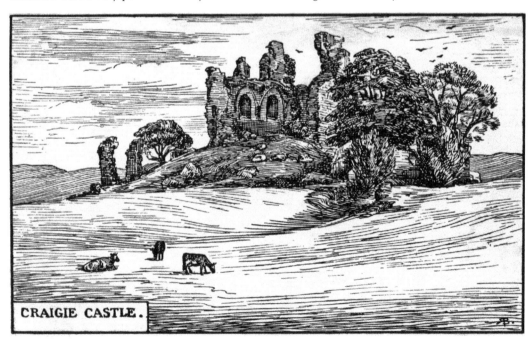

CRAIGIE CASTLE.

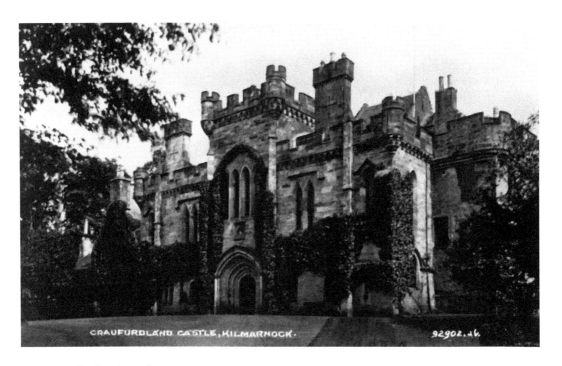

CRAUFURDLAND CASTLE, KILMARNOCK. 92902.46.

Craufurdland Castle

Craufurdland Castle has been extended and altered at various times. The Craufurds of Craufurdland have occupied the castle since the start of the thirteenth century. The present structure shows three distinct phases of construction. The main part of the front with its Gothic entrance was rebuilt in 1825. The section to the left of this was added in 1648 and the section to the right was built in the fifteenth or sixteenth century, possibly on the site of an earlier structure.

Craufurdland Loch. Near Kilmarnock.

Murdoch, Kilmarnock. H. & Co.—A

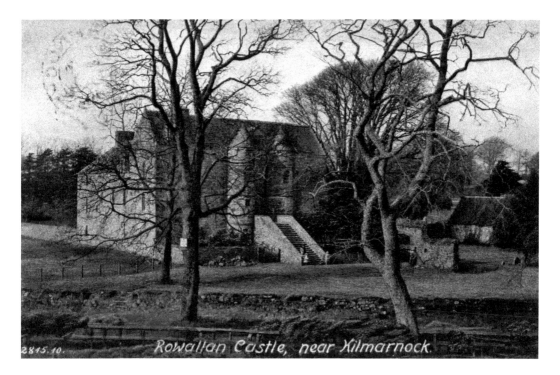

Rowallan Castle, near Kilmarnock.

2815.10.

Rowallan – Old and New

There are two Rowallan Castles. The first of them dates from the fourteenth century and was occupied until the first decade of the twentieth century when it was replaced by New Rowallan. In 1906, construction work on the New Rowallan buildings was completed for Archibald Corbett, 1st Baron Rowallan. Work had started in 1903, but the planned size was curtailed due to the death of Alice Corbett in 1902. New Rowallan was designed by Robert Lorimar, who also designed the memorial to Alice Corbett on the Fenwick Moor. With the completion of the New Rowallan, the family gave another property, Rouken Glen, to the city of Glasgow.

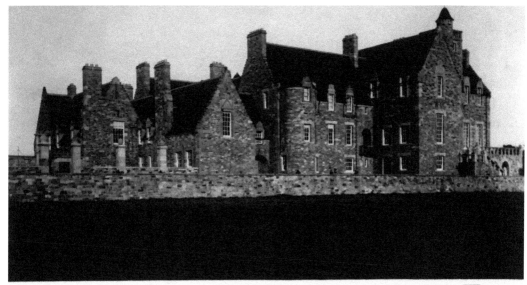

715 NEW ROWALLAN. KILMARNOCK. IDEAL ⟁ SERIES.

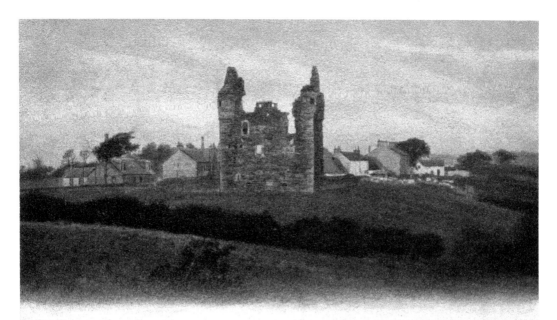

Busby Castle, Crosshouse. T. WALKER, CROSSHOUSE.

Castle and Mansion

The last remnant of Busbie Castle at Knockentiber was demolished in 1952 amid fears that the ruin might be unstable. The substantial part of the demised building probably dated from the end of the sixteenth century, though the first building on the site was built at the end of the fourteenth century. Templetonburn was more a mansion house than a castle. In the early twentieth century it was famed for the produce from the hot houses. This included figs, peaches and grapes. The estate also had a melon house.

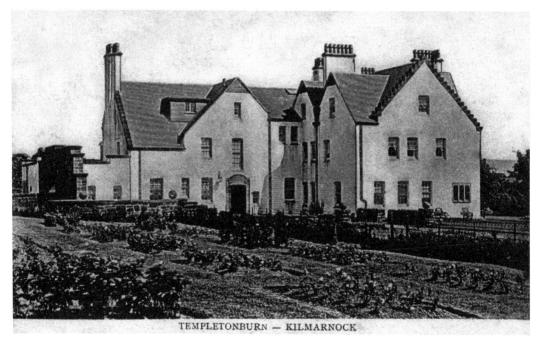

TEMPLETONBURN — KILMARNOCK

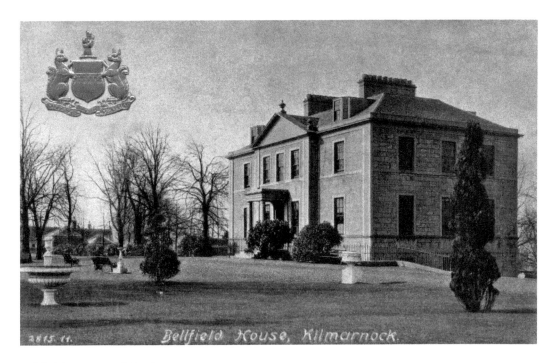
Bellfield House, Kilmarnock.

Bellfield House and Garden
With the death of Elizabeth Buchanan in 1875, Bellfield House and 240 acres of ground were given to the town along with a substantial bequest and a well-stocked library. Elizabeth and her two sisters were the daughters of a Glasgow merchant, George Buchanan. In 1888, Bellfield was opened to the public. The house and garden quickly became a favourite place for locals to visit for walks or teas. After years of neglect and lack of maintenance, Bellfield House was demolished in 1970.

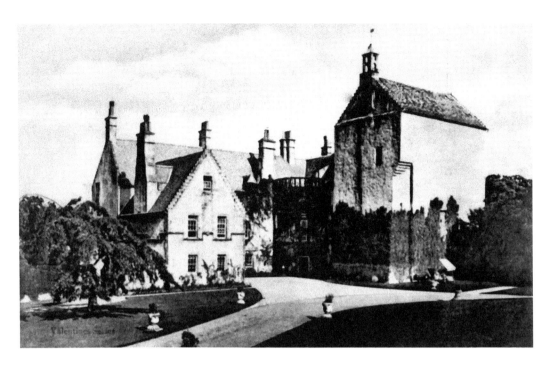

More Mansions

The oldest part of Cessnock Castle is thought to be thirteenth century and there are sixteenth-and seventeenth-century additions. Cessock was the birthplace of Robert Wallace (1773–1855). He, more than anyone else, campaigned for postal reform, and most of his plans for making the system more efficient and fairer were adopted by Rowland Hill. Dankeith was used by D-Day planners during the Second World War. It was used as a religious centre by the Passionate Fathers from around 1948–68.

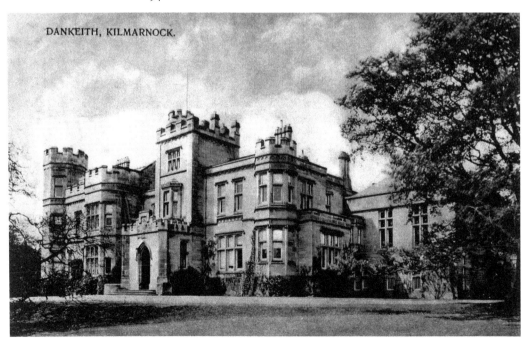

DANKEITH, KILMARNOCK.

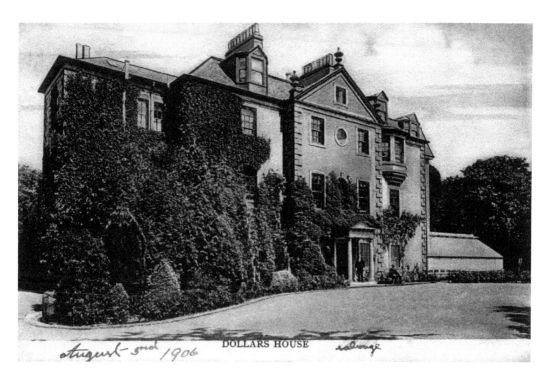

DOLLARS HOUSE

august 2nd 1906

Country Retreat

Dallars, or Dollars House, was erected in 1779. Part of the stable cottages date from 1635. In recent years, the house and grounds have been home to a riding school for the disabled and today you can get bed and breakfast in this country retreat. The mansion at Coodham House, between Symington and Kilmarnock, was built around 1830 for a Mrs Fairlie at a cost of £20,000. It was extended in 1847 to include a chapel and a stable court. The chapel had excellent craftmanship in oak, glass and marble. It is now flats.

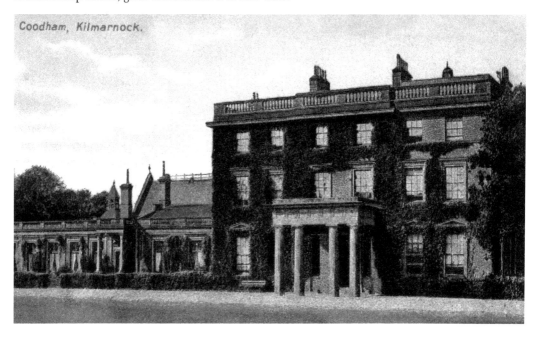

Coodham, Kilmarnock.

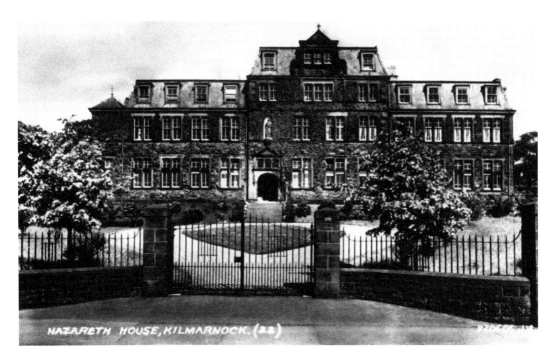

NAZARETH HOUSE, KILMARNOCK. (22)

Converted to Flats

Nazareth House was built in Hill Street in 1890 as an orphanage and old folks' home. In more recent years it was an old folks' home run by the Sisters of Nazareth. The building is now flats. Treesbank House was a mansion off the Ayr Road at the southern extremity of Kilmarnock. It was originally built by Sir Hugh Campbell of Cessnock and given to his son as a wedding present in 1672. It was substantially rebuilt 200 years later and again by carpet maker BMK in 1926.

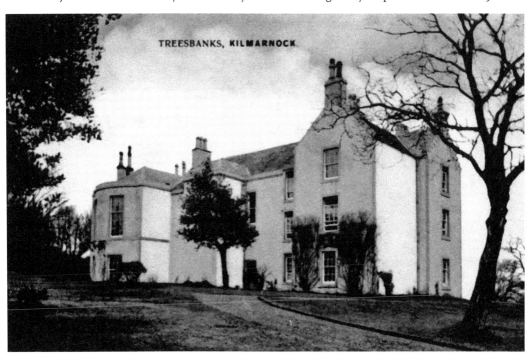

TREESBANKS, KILMARNOCK.

Millennium 1999/38
Fleming's penicillin/M Dempsey

43

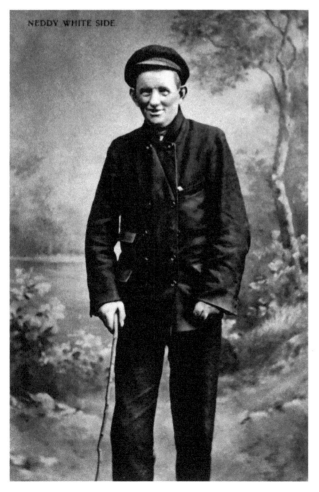

NEDDY WHITE SIDE.

People Make Communities
The work of Sir Alexander
Fleming in identifying penicillin
has saved millions of lives.
Fleming was born near Darvel
and is one of two Nobel laureates
to have attended Kilmarnock
Academy. (Postcard courtesy of
Royal Mail.) It wasn't just the
great people who found their
way on to local postcards. Neddy
Whiteside was a simple soul,
described in the language of his
day as 'a local character'.

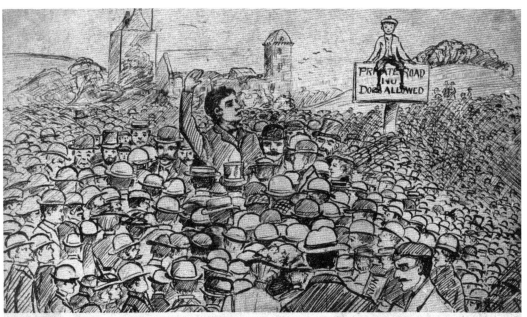

DEAN RIGHT-OF-WAY DEMONSTRATION, KILMARNOCK, 30th AUGUST, 1908 Rodger, Stationer, Kilmarnock

People in Protest

In 1908, a dispute between the local landowner and the people of Kilmarnock broke out when a gate barrier was placed on the route to Dean Park, closing off a right of way. Local stationer, Tommy Rodger, quickly produced a postcard of the protest. Another local character who attracted the attention of postcard makers was Willie Hats, a gentle soul who seems to have got his name from the number and variety of headgear he wore.

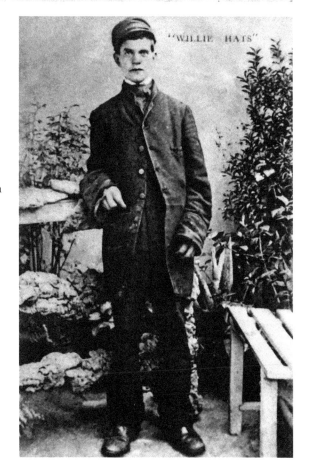

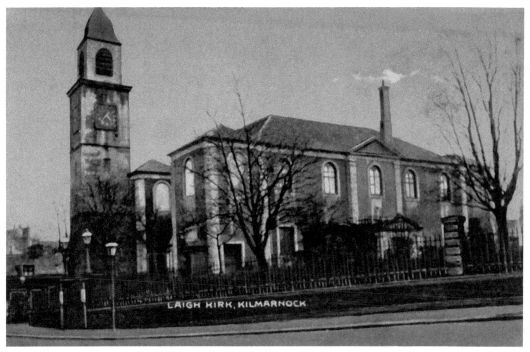

LAIGH KIRK, KILMARNOCK

Laigh Kirk. 12/2/05 Kilmarnock.

There are two Ministers in
this Church. Some fine singing in
it, The sittings are all taken up

The Town's First Church

Today's New Laigh Kirk is on the site
of the first church in Kilmarnock but
whether the church was attracted to a
community or a community to a remote
church is not known. It certainly goes
back to the earliest days of Christianity
in Ayrshire. The present building
dates from 1802. In 1801, a disaster
overwhelmed the congregation when
they thought the building was falling
down. Thirty people died in the mad
stampede to get out. After that accident
the old building was demolished and
the present one constructed with
numerous exits.

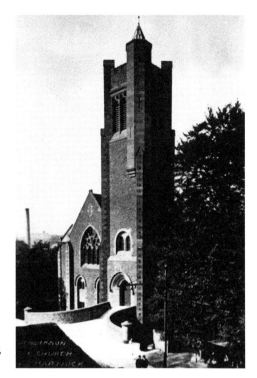

A Kirk and its Minister

Revd Dr David Landsborough (1826–1912) was the son of Revd David Landsborough of Stevenston. The younger David was a minister, naturalist and historian. As a keen botanist, he introduced several trees and plants to the Isle of Arran. He was also an avid collector and student of geology. His collection of communion tokens went to the Dick Institute. He was a fine minister who built a strong congregation in Henderson Church, now the Kay Park Parish Church, where he was minister for the sixty-one years from 1851 to 1912.

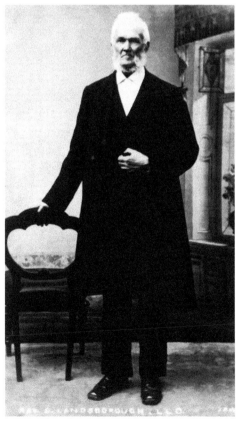

THE ENGLISH CHURCH, KILMARNOCK.

A Variety of Churches

The majority church group is the Church of Scotland, but there are others. The Holy Trinity Scottish Episcopalian Church is often wrongly described as the English Church. It is situated at the corner of Dundonald Road and Portland Road. It was rebuilt and extended in 1876, mostly at the expense of William Houldsworth of Coodham. In 1847, St Joseph's Church was opened for worship at Hill Street. It was the first Roman Catholic church in Kilmarnock since the time of the Reformation. In 2002, the church and associated priest's house was made a listed building with category B status.

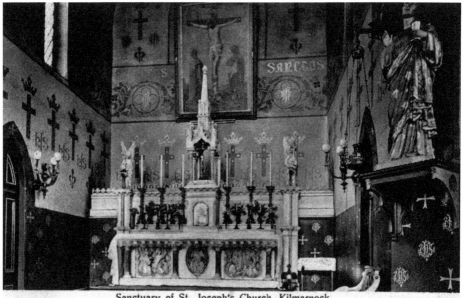

Sanctuary of St. Joseph's Church, Kilmarnock

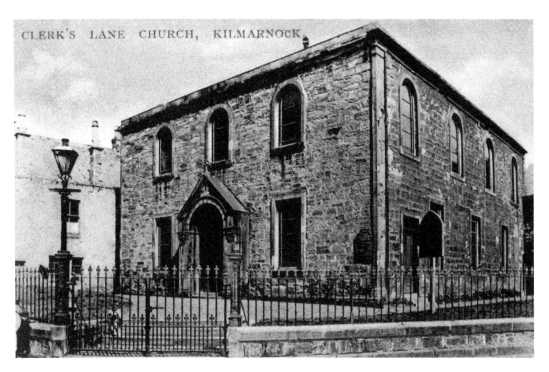

CLERK'S LANE CHURCH, KILMARNOCK.

Church Mergers

Glencairn Church in West Shaw Street near Glencairn Square dates from 1881. The building replaced the earlier Holm Church Mission on the same site. In 1967, the congregations of Glencairn Church and Saint Andrew's Church united under the title of Saint Andrew's Glencairn. This Glencairn church building was demolished in 1993 and the St Andrew Church building is now flats.

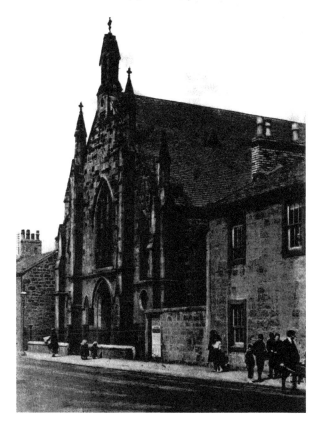

Glencairn U. F. Church, Kilmarnock.

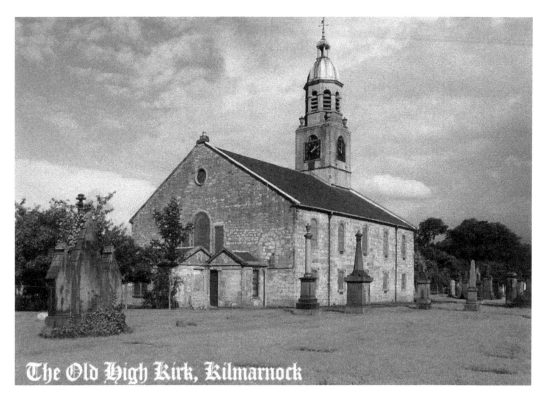

The Old High Kirk, Kilmarnock

No More Worship

The Old High Church dates from 1731, having been built to accommodate a growing population. In the kirkyard there are stones to many prominent local citizens. Today, this old church building is a funeral home. In 1807 the congregation of the Clerk's Lane Church reconstructed their 1774 building on the same site. It closed in 1907 and the building became the Electric Theatre, Kilmarnock's first cinema in 1911.

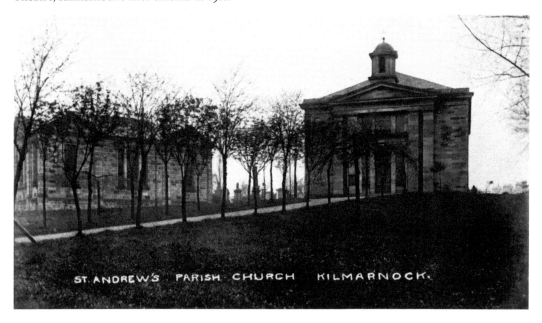

ST. ANDREW'S PARISH CHURCH KILMARNOCK.

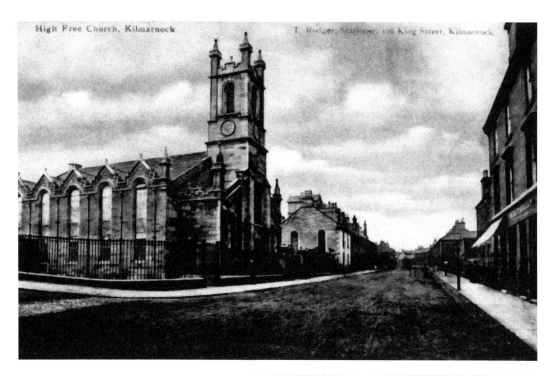

Town Centre Churches

The West High Church was built in 1844 and extended in 1881. In 2000, the congregations of the West High Church and the Laigh Kirk agreed to a merger and the West High building was converted for business use. St Andrew's North Church was established in 1843 in a building in Fowlds Street. The building was demolished in 1986. The site became a shop.

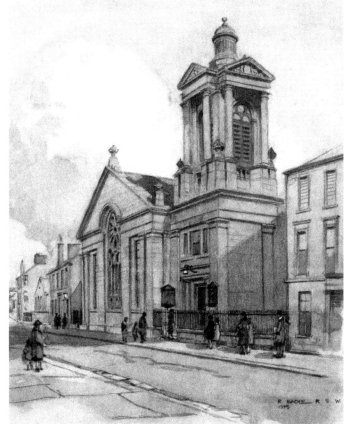

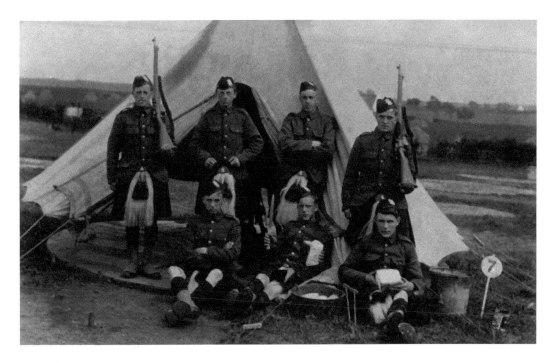

Men of War

In 1911, the British Army held a major camp at Woodlands near Kilmarnock, involving men from all over the country. The camp had its own post office and this postcard shows men of the Black Watch, who may have been from the local area. By 1915, the war was claiming an unprecedented number of lives and leaving huge numbers injured. Many community efforts were organised to raise funds for the men and their families.

LOWLAND REGIMENTS BADGE DAY: JUNE 19TH, 1915
TO ASSIST SOLDIERS DISABLED AND INVALIDED AT THE FRONT.

1. ROYAL SCOTS GREYS
 (2nd Dragoons)
2. H.M. SCOTS GUARDS.
3. ROYAL SCOTS.
4. ROYAL SCOTS FUSILIERS.
5. KING'S OWN SCOTTISH
 BORDERERS.
6. CAMERONIANS
 (Scottish Rifles)

McLAGAN & CUMMING, EDIN^R

THE "LUSITANIA."

Oh Lusitania, with souls e'er so dear,
That crossed the wide ocean regardless of fear:
Tae think o' the crying — baith mithers and weans —
Oh cruel-hearted Kaiser, you should be in flames.

Oh Lusitania! Who could not but weep
For souls that perished in crossing the deep:
Though people in Berlin took pride at your fall —
The cruel-hearted Kaiser was cause of it all.

Copyright — Robert Orr, 11 Nursery Avenue, Kilmarnock.

Act of War

Controversy still surrounds the sinking of the passenger liner *Lusitania* by a German submarine crew in 1915. Among the local people killed were James Barr and his wife, Kate. James was the eldest son of John Barr, a director of Glenfield and Kennedy. Some of the war dead were buried in the town cemetery, which was opened at Grassyards Road in 1875. The gatehouse, with its tower and decorative wrought-iron gates, was given category B listed building status.

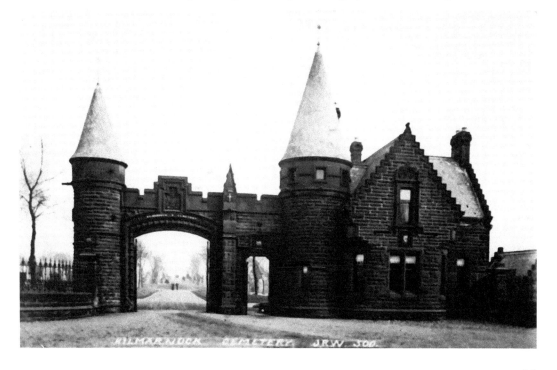

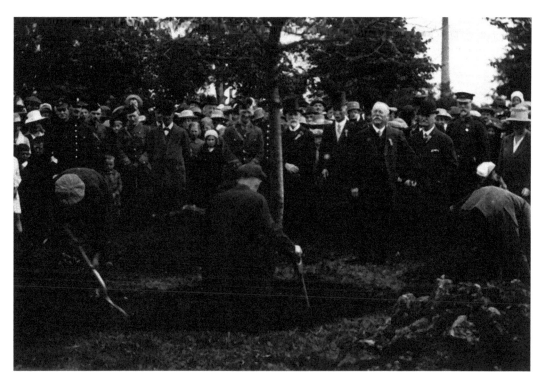

When Peace Broke Out

Many events were held across the country in 1919 to mark the end of the war. This had been agreed in November 1918. In Kilmarnock the celebrations included the planting of a peace tree in the Howard Park and a parade through the town.

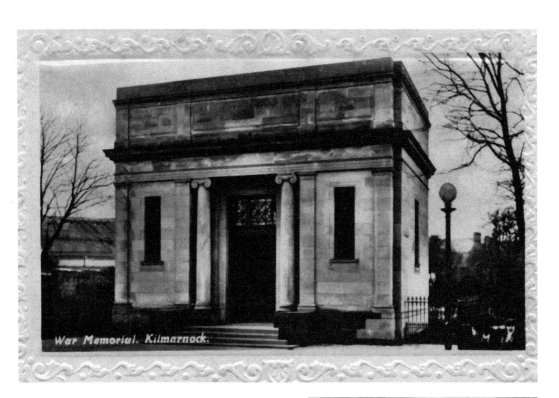

War Memorial. Kilmarnock.

Remember the Dead

During the First World War 26 per cent of the 557,000 Scots who enlisted were killed, more than double the rate for the UK as a whole. Every parish has its own war memorial. In Kilmarnock the war memorial today contains the names of local men killed in both world wars and subsequent conflicts, such as those in Korea and Northern Ireland. The memorial also contains a statue called *The Victor*, who is contemplating the human cost of war.

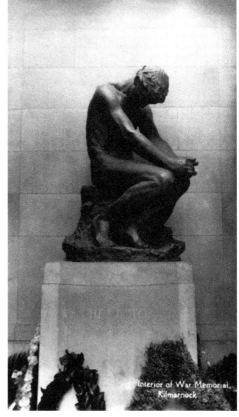

Interior of War Memorial, Kilmarnock

SECTION 3

INDUSTRY AND TRANSPORT

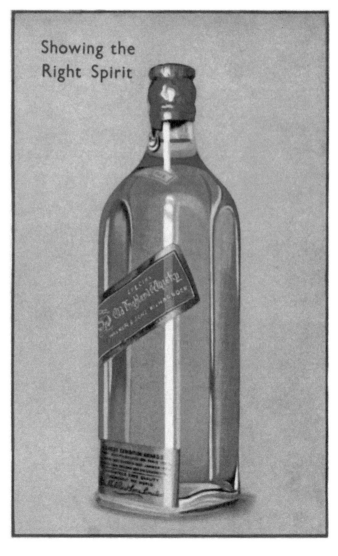

Johnnie Walker whisky is recognised everywhere.

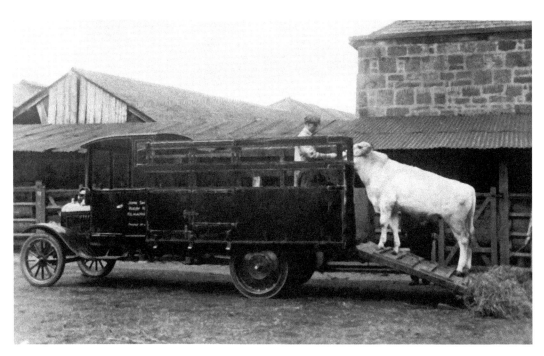

From the Land

Agriculture was crucial to the development of the town and agricultural shows were a chance for local farmers to show off their animals and their produce. At the start of the twentieth century Kilmarnock was home to some of the biggest cheese fairs in the country.

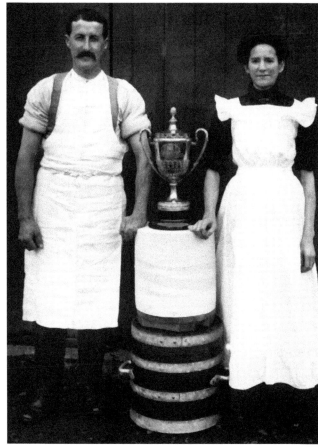

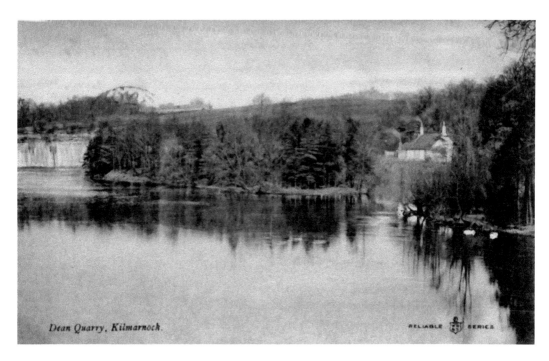

Dean Quarry, Kilmarnock.

RELIABLE SERIES

From the Ground

Kilmarnock was rich in coal and other minerals. There were several quarries in and around the town that produced clay for making bricks as well as sandstone for building work. Many of the early prominent buildings around Kilmarnock were built of Dean Quarry stone.

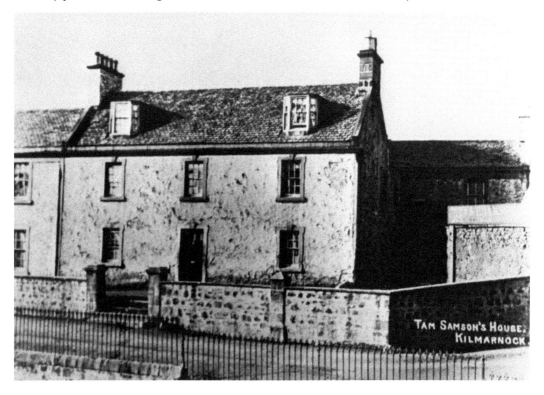

TAM SAMSON'S HOUSE, KILMARNOCK

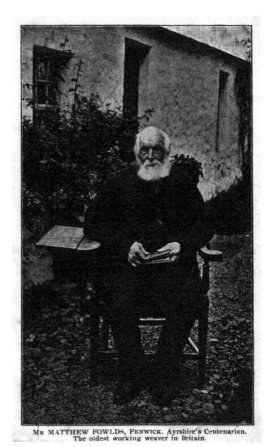

From Handloom to Factory

Sheep from local farms provided wool for a variety of products and in the early days much of the work was done on hand looms. Matthew Faulds was a weaver who was still working at the age of 100. As things progressed big businesses emerged. BMK carpets was founded in Kilmarnock and earned a reputation across the world for quality carpets.

Mr MATTHEW FOWLDS, FENWICK. Ayrshire's Centenarian. The oldest working weaver in Britain.

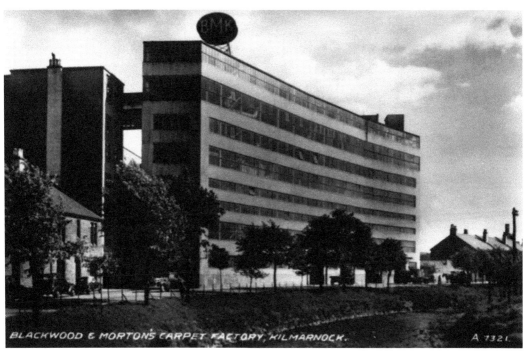

BLACKWOOD & MORTON'S CARPET FACTORY, KILMARNOCK. A 7321.

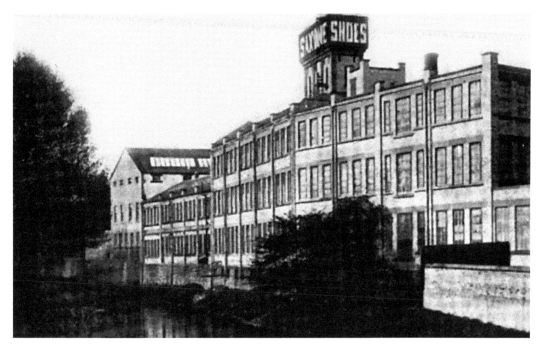

SLUICE VALVES

EVER since the first valve left our works over sixty years ago, perfection in design, materials and workmanship has been our aim. Proof of this is available in the high reputation enjoyed by Glenfield Sluice Valves today.

GLENFIELD AND KENNEDY LIMITED KILMARNOCK

We also make Sandwashers, Hydrants, Drinking Fountains, Rotary Meters, Hydraulic Stop Valves, Penstocks, Hydro-Electric Control Valves, Sluice Gates for Irrigation, etc.

If the Boot Fits

Another ancient craft emerged into a world leader. Working leather was an early craft in Kilmarnock and so was the making of boots. This grew into Saxone. In the middle of the twentieth century Saxone was a major producer of boots and shoes and had shops all over the country. BMK and Saxone were not the only Kilmarnock companies with an international reputation. Glenfield and Kennedy was a major employer and innovator in hydraulic engineering.

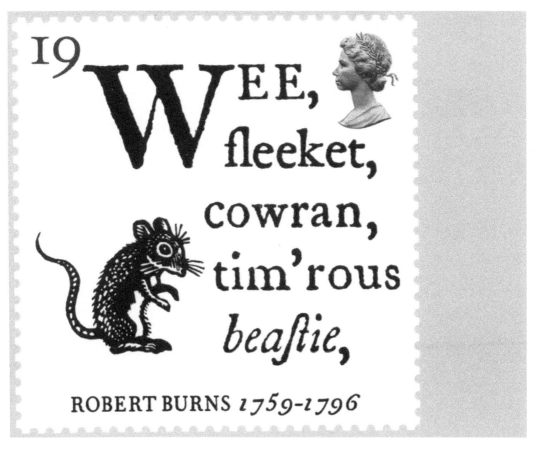

Recognised Everywhere

The name Johnnie Walker is known across the world. The company grew from a small grocery shop in Kilmarnock to become a major producer of blended whiskies and one of the world's first global brands. Industries need printed material and one of the earliest printers in Kilmarnock was John Wilson, who famously produced the first book of poems by Robert Burns. His typeface was later used on a postage stamp. (Postcard picture courtesy of Royal Mail)

JOHNNIE WALKER

FORE-MOST SINCE 1820

STILL GOING STRONG

THE WHISKY THAT GOES WITH A SWING

19

Wee, fleeket, cowran, tim'rous beaſtie,

ROBERT BURNS 1759-1796

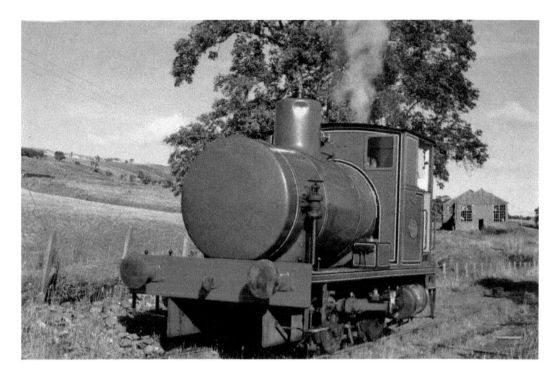

On the Move

Scotland's earliest railway was between Kilmarnock and Troon and this line had a timetabled passenger service from 1812. The engineering required led to new opportunities. Andrew Barclay set up his engineering business in 1840. In 1859, the company built their first steam locomotive. Soon they would be known as builders of specialised steam locomotives.

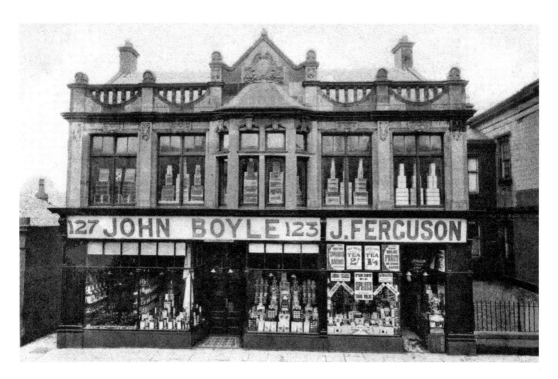

Shops for Everyone

There was a time when every town had its own drysalter shops. They dealt in goods like dye and colouring products, glue, varnish and sometimes in preserved foods. John Boyle had a shop in King Street with rather distinctive architecture. The dominant retail force in Kilmarnock in the early years of the twentieth century was the Co-op, which had branches throughout the town.

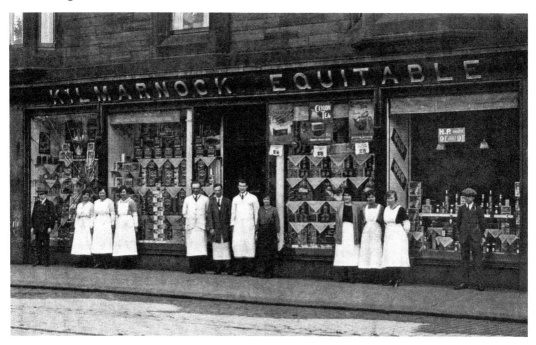

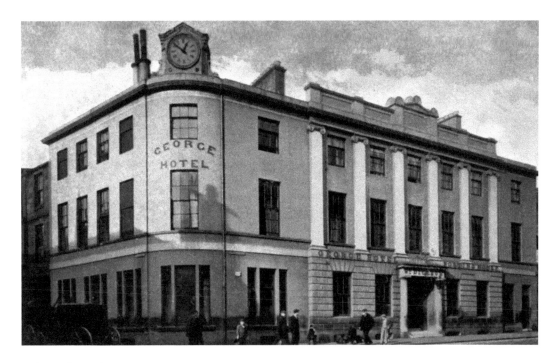

Pubs and Hotels

The top hotel in Kilmarnock in the later part of the nineteenth and early twentieth century was the George Hotel. It was closed in 1920 after nearly 100 years. In its heyday it had been the venue of choice for functions and receptions held by Kilmarnock Town Council. Today the building is a furniture shop. One of Kilmarnock's oldest pubs is now known as Fanny by Gaslight. It has a history going back to the 1840s.

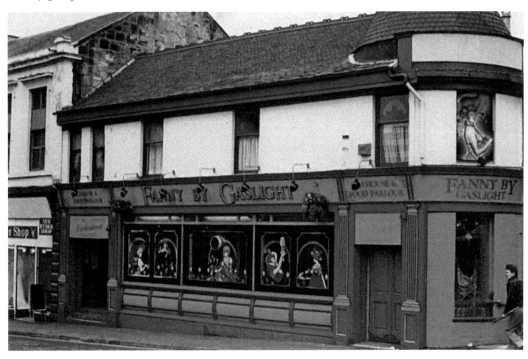

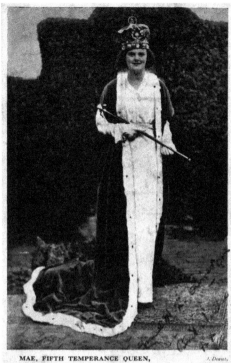

MAE, FIFTH TEMPERANCE QUEEN, KILMARNOCK, 1938-9. J. Deant, Kilmarnock,

Campaign for Temperance

There is, perhaps, an irony in that the town that gave the world Johnnie Walker whisky also had a vibrant temperance movement, which for many years held a festival and chose a Temperance Queen.

EMMA, 20th TEMPERANCE QUEEN, KILMARNOCK, 1953 [Photo, Hamilton]

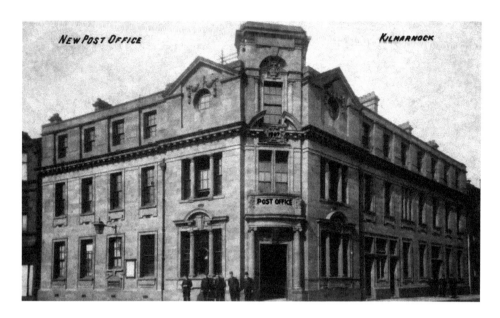

Mark of the Post

Kilmarnock was one of the first post towns in Scotland. It has had a post office since 1661, but this was not because Kilmarnock was an important place. It was simply a convenient stop on the route from Edinburgh to Portpatrick, and on to Dublin. The post office building in the picture was opened in 1907 and closed at the end of 2016 when services were relocated. If you are in town to conduct postal or any other business, the town has a wide variety of cafés. The Coffee Club was established in Bank Street in 1959 and quickly earned a good reputation.

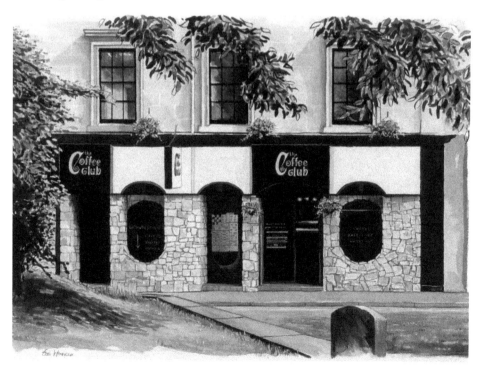

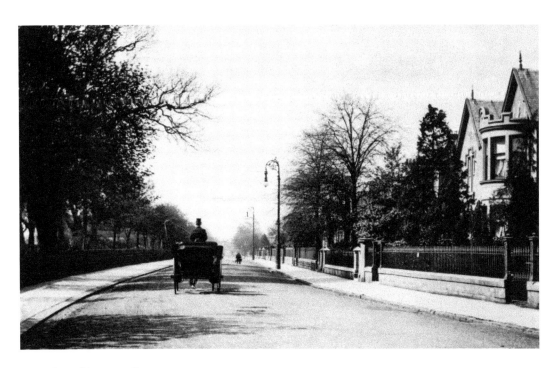

From Horse to Car

There was a time when if you wanted to get around, you walked. If you were well off you might have a horse and coach. In 1896, something novel was seen in Kilmarnock. Douglas Dick brought a motor car to his home town. This was pioneering work, for the first petrol-driven vehicle in Scotland had only arrived at Leith in October of 1895.

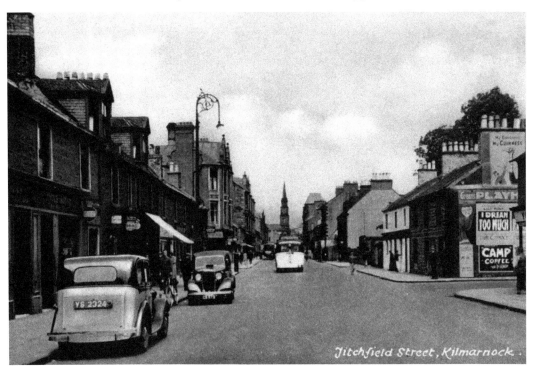

Titchfield Street, Kilmarnock.

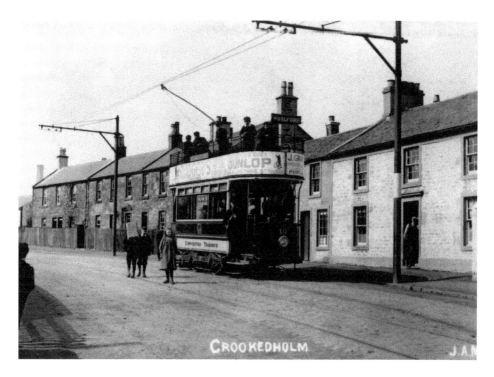

CROOKEDHOLM J.A.

Electric Trams

After furious public arguments, Kilmarnock Town Council started a tram system in the town in 1904. This had the benefit of requiring a power station and so a public electricity station was also built with a supply being made available to customers throughout the district. There were two types of tram on the system: the open topped and the so-called double-deckers. The system closed in 1926.

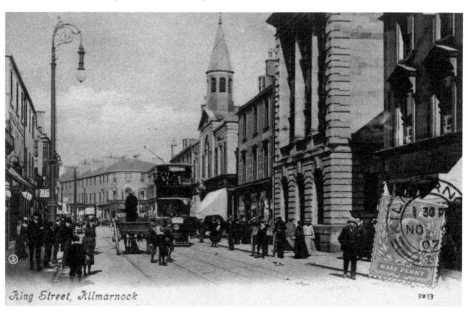

King Street, Kilmarnock 2213

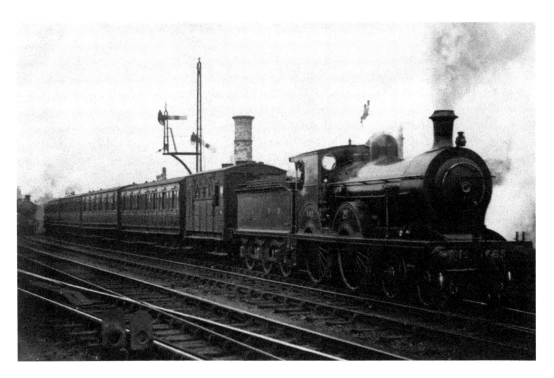

Rails to Everywhere

Kilmarnock and Troon were linked by a railway in 1812. Although intended for coal traffic, the line had a timetabled passenger service from June 1812. In 1843, the Glasgow, Paisley, Kilmarnock & Ayr Railway opened a branch line from Kilmarnock to Dalry and therefore to Glasgow. Other lines soon followed.

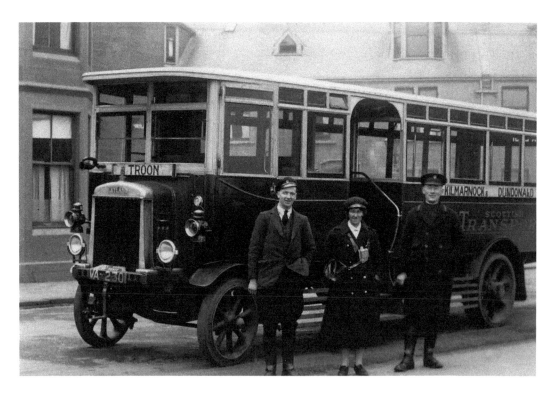

Early Buses

In the first years of the twentieth century many people wanted to operate a bus service to help move people around. Gradually these independent traders came together and created new companies. In 1923, a new bus station was opened in Portland Street. It was one of the first custom-built bus stations in Scotland. It was replaced in 1974.

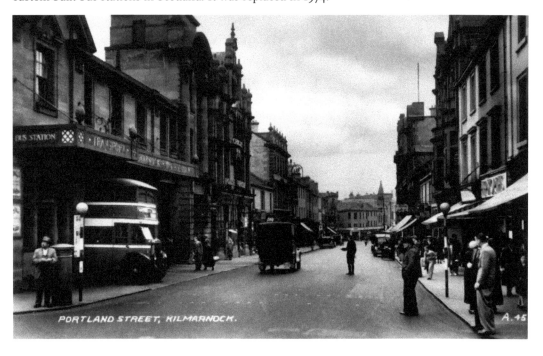

PORTLAND STREET, KILMARNOCK.

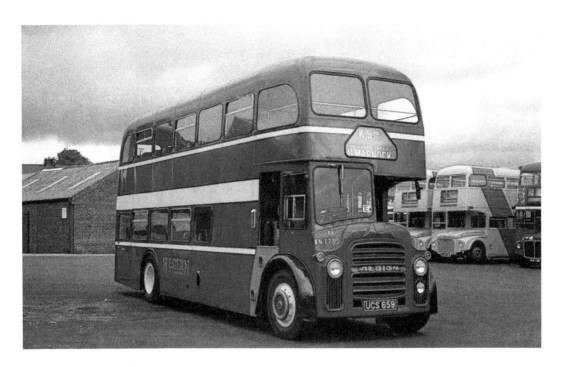

Western Scottish

Western Scottish, also known as SMT, came to dominate bus services across the west of Scotland. They had their headquarters and their engineering facilities in Kilmarnock. As well as local services, the company ran day tours, mystery tours and long-haul services to far off places like London. The company produced a series of postcards of many of their buses. Today, Western SMT is part of Stagecoach.

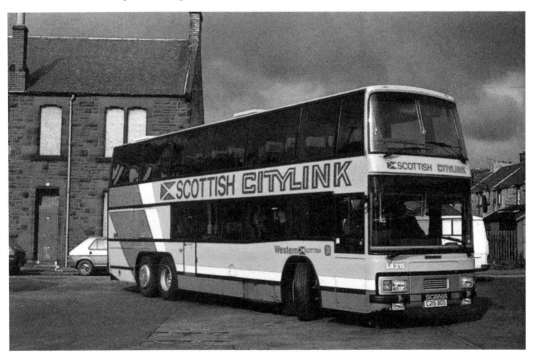

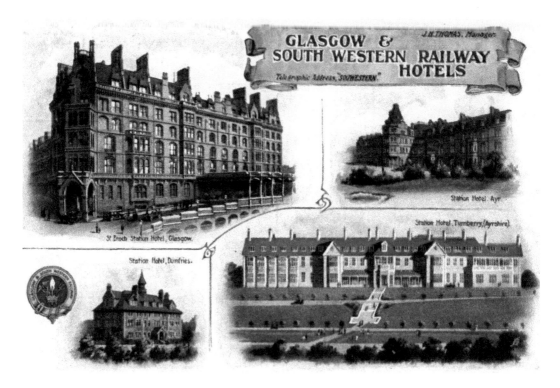

Travellers' Tales

Railway companies and others produced a variety of postcards in the days when travellers wanted to send a message home. The Glasgow & South Western Railway had its engineering services in Kilmarnock, but they also had hotels including the one at Turnberry.

SECTION 4

COMMUNITY SERVICES AND LEISURE

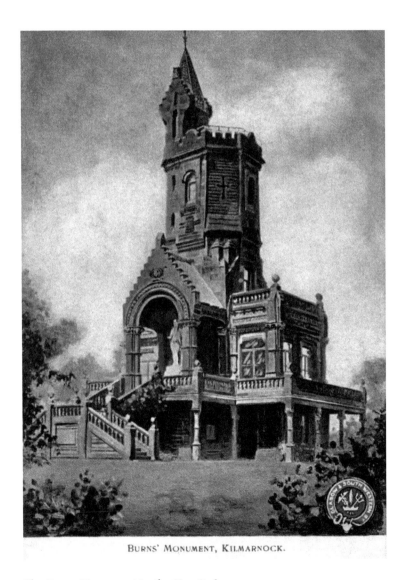

BURNS' MONUMENT, KILMARNOCK.

The Burns Monument in the Kay Park.

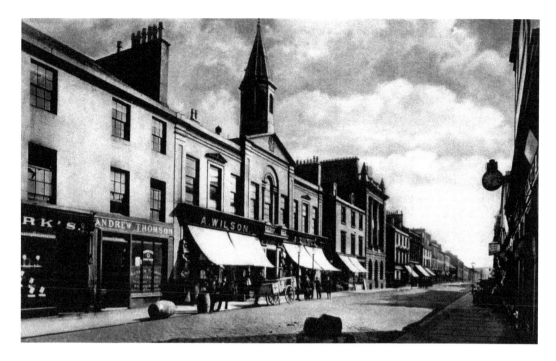

Pride of the Town

The town house with a distinctive tower was built in 1804–05 on the new bridge over the
Kilmarnock Water. It was the civic headquarters for the burgh. The building included offices
for magistrates, the law courts and a jail. In 1828, the library room was converted to a station
for the new burgh police. The Dick Institute was opened in 1901 as the cultural centre for the
Kilmarnock area. It housed the town's library, art gallery and museum and still does so today.

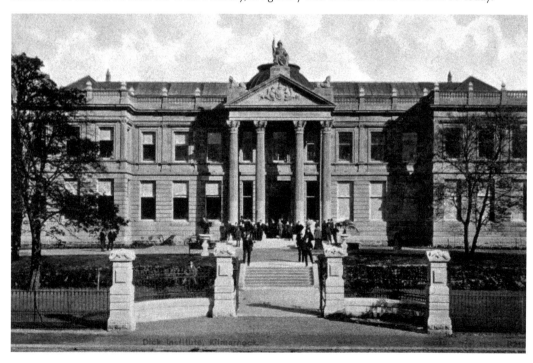

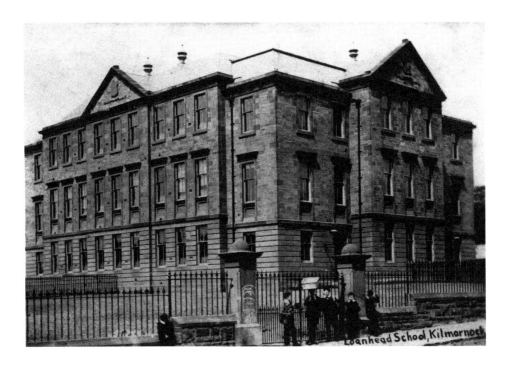

Loanhead School, Kilmarnock

Education is a Priority

Education became a priority in Scotland in 1633 when the Scottish Parliament, the original one, passed an Act to establish a school in every parish in the country. Today, education remains a high priority with university tuition fees paid by the state. In 1903, Andrew Carnegie visited Kilmarnock and laid the foundation stone of Loanhead School. The burgh school and the parish school were united in 1808 to form Kilmarnock Academy. The picture shows the academy building of 1898.

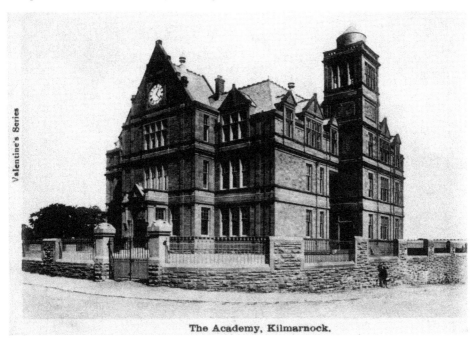

Valentine's Series

The Academy, Kilmarnock.

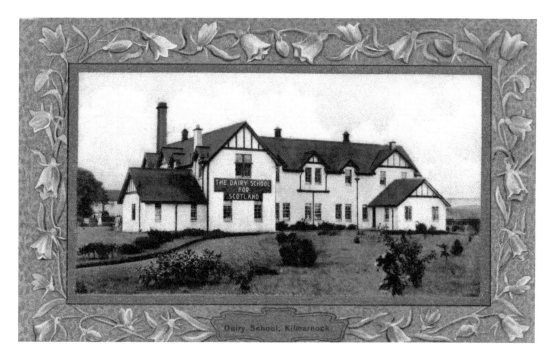

Dairy School, Kilmarnock

Focused Education

With agriculture a vital part of the Scottish economy, a Dairy School for Scotland was established at Kilmarnock in 1889. As well as a teaching facility, the Dairy School conducted experiments, including one attempt at finding a strain of tobacco plant that could stand the Scottish climate. Eventually, the school outgrew the buildings and moved to Auchencruive, near Ayr. With Kilmarnock being an industrial town, an upgraded engineering college or Technical School was opened at Dick Road in 1909.

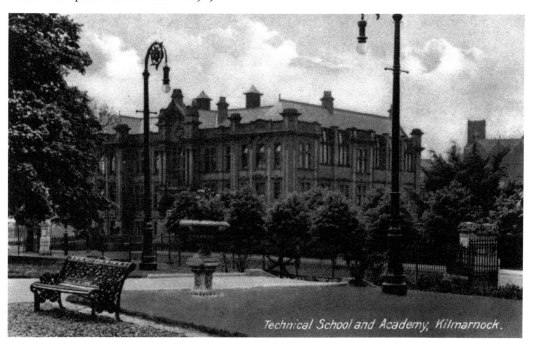

Technical School and Academy, Kilmarnock.

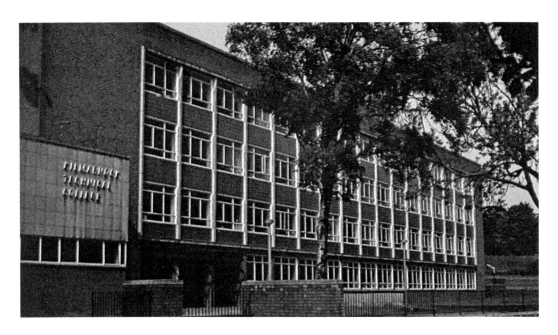

Technical Education

Kilmarnock Technical College was opened at Holehouse Road in 1966 to replace the technical school in Dick Road. It later dropped the term 'technical' to become Kilmarnock College and later still became the Kilmarnock campus of the Ayrshire College. In December 2016, First Minister Nicola Sturgeon opened the new Kilmarnock campus building of Ayrshire College at Hill Street.

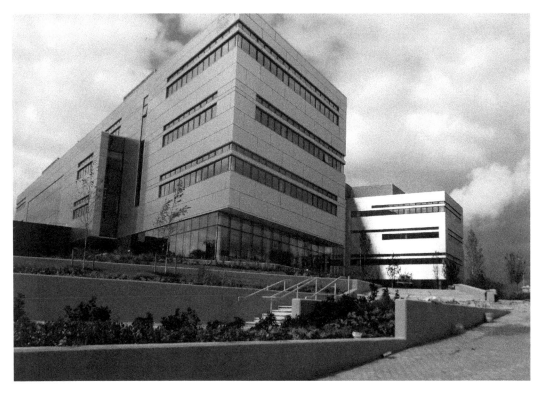

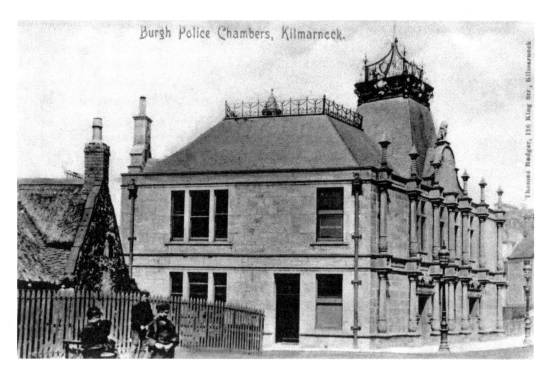

Burgh Police Chambers, Kilmarnock.

Thomas Redger, 126 King Str., Kilmarnock

Law of the Land

The burgh police station at Sturrock Street was opened in 1898 and served the town until a new station was opened in St Marnock Street in 1978. The old building was then demolished. The town's Sheriff Courthouse was opened in St Marnock Street in 1852. It was replaced by a new Sheriff Courthouse just across the road. The vacated property became the office of the Procurator Fiscal.

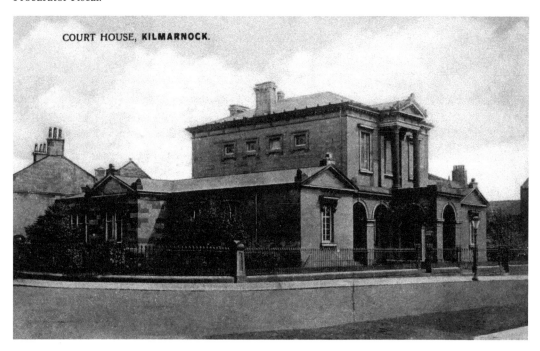

COURT HOUSE, KILMARNOCK.

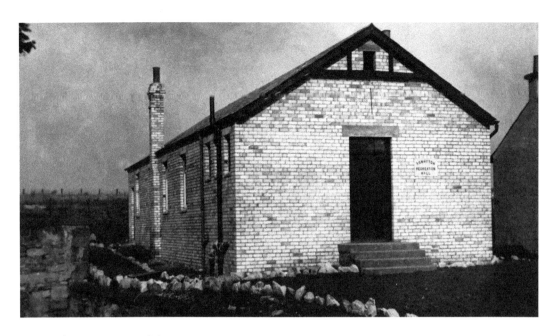

Other Leisure Facilities

Not all leisure and public service buildings are on a grand scale. The Bonnyton Recreation Hall was opened in October 1924 after a fundraising effort by the community. Leisure facilities are not just buildings. When Dean Castle was given to the town in 1975, it came with internationally important collections of arms, tapestries and musical instruments. The castle and surrounding country park is now the area's top tourist attraction.

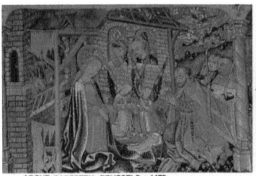

ABOVE: TAPESTRY - BRUSSELS, c.1475
BELOW: SPINET - ITALIAN

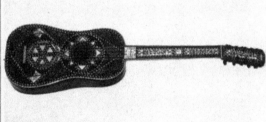

ABOVE: GUITAR - M. STREGHER, 1621
BELOW: ARMOUR - "MAXIMILIAN"

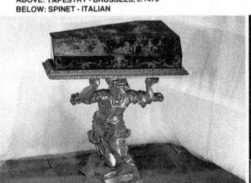

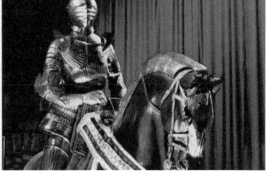

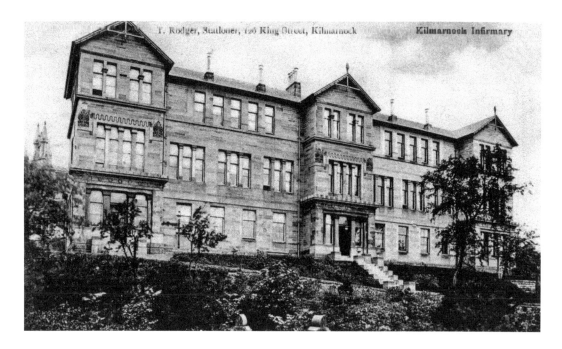

In Good Health

The best investment a nation can make for the future is in the health and education of its citizens. Kilmarnock Infirmary opened at Mount Pleasant in Wellington Street in 1868. It was extended several times, and in 1921 the original hospital building became the nurses' residence. It was replaced by Crosshouse Hospital in 1983. Kirklandside Hospital was opened as a fever hospital in 1909. Today it is a recuperation facility.

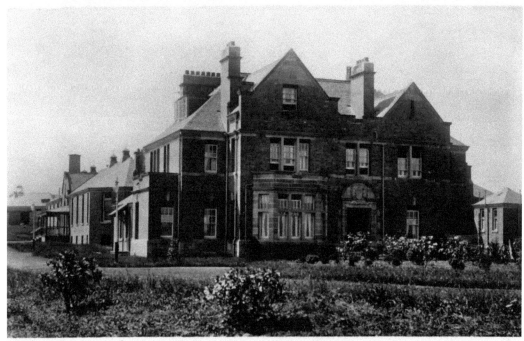

No 316 KIRKLANDSIDE FEVER HOSPITAL, KILMARNOCK.

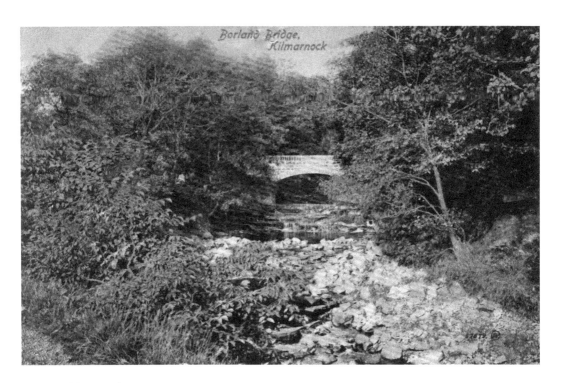

Borland Bridge,
Kilmarnock

Building Bridges

The bridge, over the Fenwick Water, close to Dean Castle, is sometimes referred to as the Dean Bridge and sometimes as the Duke's Bridge. Just downstream after the river becomes the Kilmarnock Water there was a suspension footbridge known as the Lauder Bridge. The original bridge was opened in 1905 but collapsed at the opening ceremony. It was rebuilt. The new one was replaced in 2015.

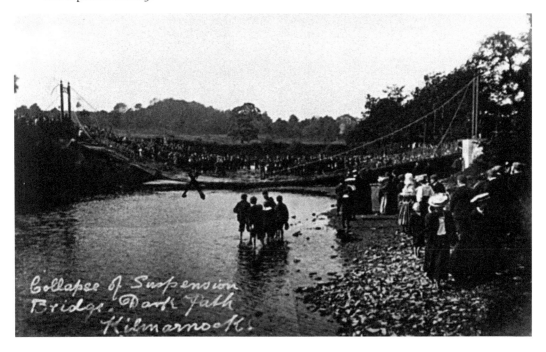

Collapse of Suspension Bridge. Dark Path Kilmarnock.

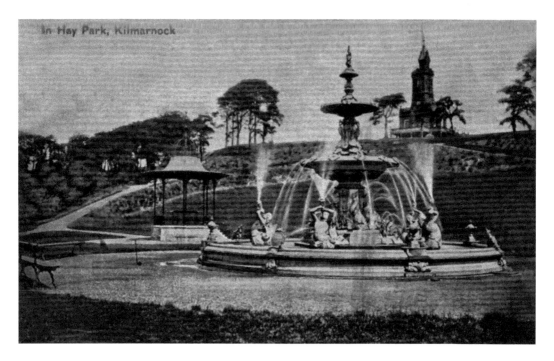

In Kay Park, Kilmarnock

Kay Park Fountains

The Kay Park once had two water fountains. The most elaborate was a fine cast-iron fountain made at Coalbrookdale in Shropshire. It was 22 feet 9 inches high and the base was 30 feet 6 inches in diameter. It had five 5-foot-high mermaids who blew water from shells. In all, the whole fountain complex had fifty-one separate jets of water. The fountain was said to be one of the best in the whole country but it was broken up for scrap during the Second World War. A second fountain marks the coronation of Edward VII.

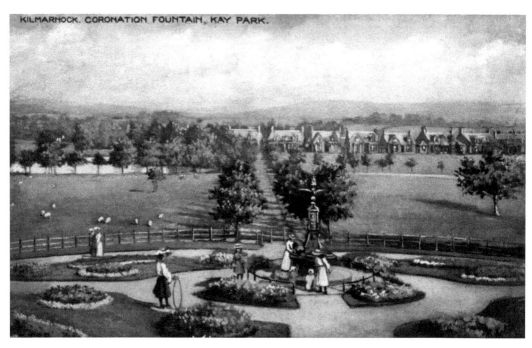

KILMARNOCK. CORONATION FOUNTAIN, KAY PARK.

Kay Park

Reformers who campaigned for a fairer voting system in the early nineteenth century are commemorated with a monument in Kay Park. Their success was limited and it took many other generations to extend the franchise to all male adults, eventually to women and ultimately to win back Scotland's parliament. The column was originally surmounted by a female statue symbolising liberty, but it was blown off during a storm in 1936. The park has always been a popular venue for major events. The crowd in this picture is thought to be attending a peace event in 1919.

Reformers Monument, Kay Park, KILMARNOCK.

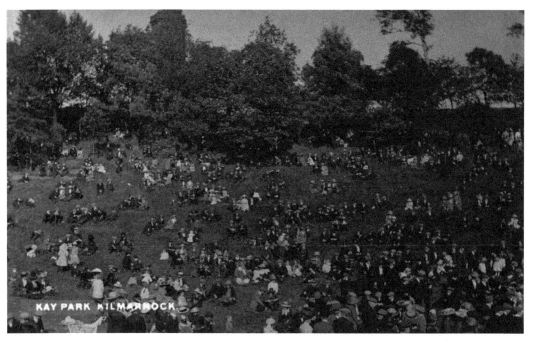

KAY PARK KILMARNOCK

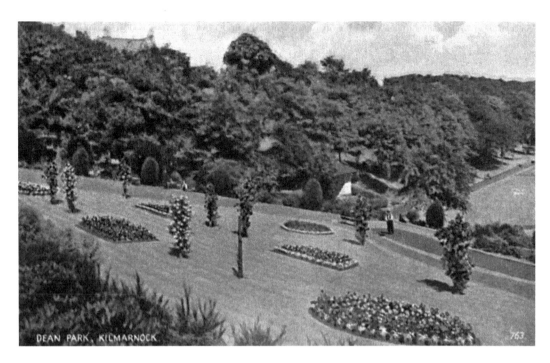

Dean Park

The land that was used to create the Dean Park was given to the people of the town by Lord Howard de Walden in 1907. It soon became a favourite place for sports as well as for walks in the gardens. Dean Park consists of more than 23 acres. Land there had long been used for public events and at one time had been known as the Toll Park.

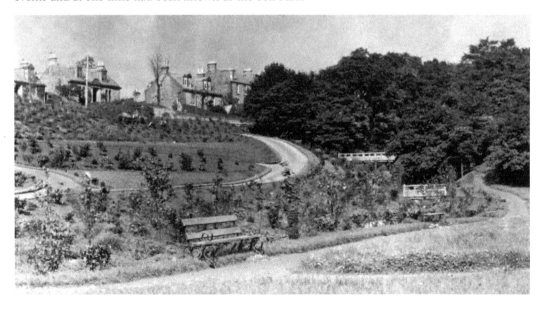

BARBADOES — HOWARD PARK — KILMARNOCK

Howard Park

Part of Howard Park was previously Wards Park and Barbadoes Green, originally the grounds of Kilmarnock House. The park was given to the town by Lord Howard de Walden and opened in 1894. It contains a mass grave to victims of cholera, a memorial to doctor Alexander Marshall and a memorial to victims of Sukhum in Abkhazia, who were killed in the 1992–93 civil war. In the park, you can trace the original course of the Kilmarnock Water by following a high banking of the Lady's Walk.

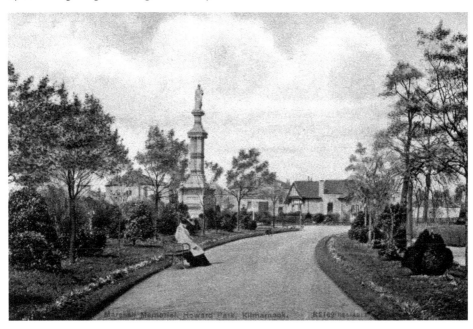

Marshall Memorial, Howard Park, Kilmarnock.

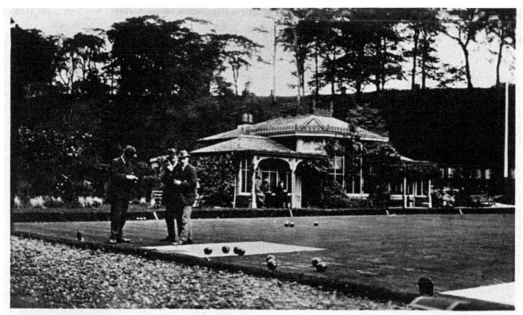

K.80. KILMARNOCK BOWLING GREEN.

Kilmarnock's Place in Bowling History

Kilmarnock Bowling Club was established in 1740 near the Cross. They moved to Mill Lane in 1824, but in 1826 the land was required for a church and they moved to the present site off London Road. The club is the oldest bowling club in Scotland and their members helped formulate today's standard rules of the game. The Portland Club was founded in 1860, mainly by local businessmen. It has an interesting clubhouse.

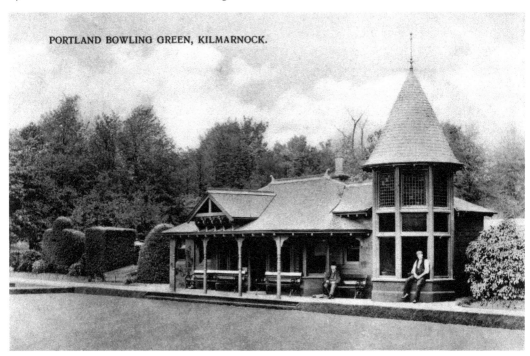

PORTLAND BOWLING GREEN, KILMARNOCK.

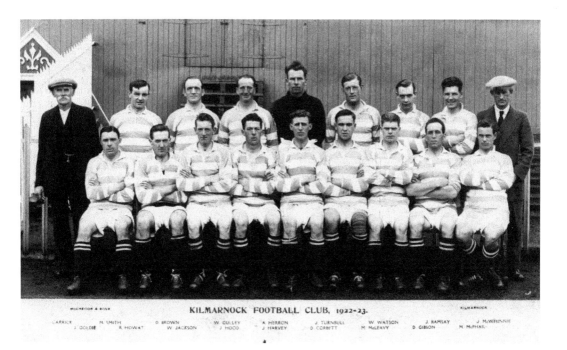

KILMARNOCK FOOTBALL CLUB, 1922-23.

CARRICK M. SMITH D. BROWN W. CULLEY A. HERRON J. TURNBULL W. WATSON J. RAMSAY J. McWHINNIE
J. GOLDIE R. HOWAT W. JACKSON J. HOOD J. HARVEY D. CORBETT M. McLEAVY D. GIBSON M. McPHAIL

Kilmarnock Football Club

Kilmarnock Football Club was founded in 1869 and is one of the oldest professional clubs in the country. Like so many other clubs, Kilmarnock FC is very much part of the community and has had many ups and downs. Curiously, Kilmarnock Football Club's home ground is Rugby Park.

Supplement to IDEAS.

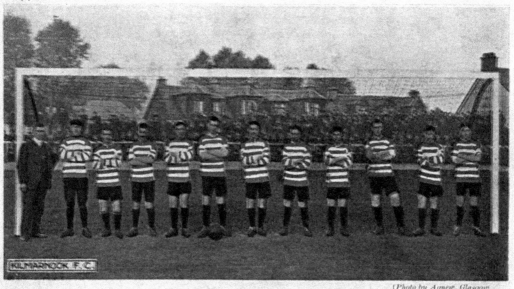

[Photo by Agnew, Glasgow.

C. THOMAS (Trainer). STEVENSON. KIRKWOOD. MITCHELL. HALLEY. BARRIE. GLASS. ARMOUR. RAMSAY.
DOUGLAS. HASTIE. TEMPLETON.

89

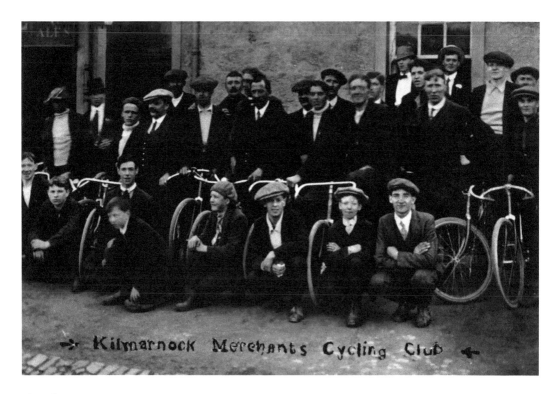

> Kilmarnock Merchants Cycling Club ←

Time for Leisure

Cycling has been popular in Kilmarnock since the nineteenth century. In 1871, Thomas McCall started the manufacture of bicycles in Kilmarnock. He had seen Kirkpatrick Macmillan's bicycle in the 1840s and improved on the design. If you cycled to one of the parks at that time, you could be sure of entertainment from one of the local bands. Most of the parks had a bandstand.

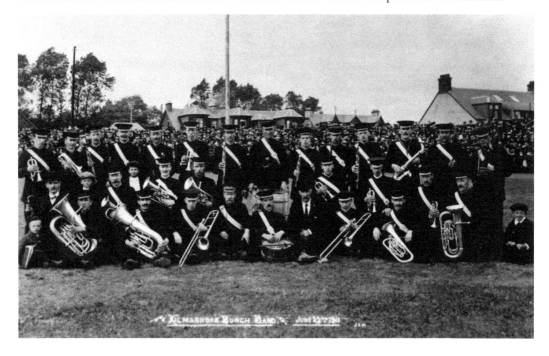

Kilmarnock Burgh Band June 22nd 1911

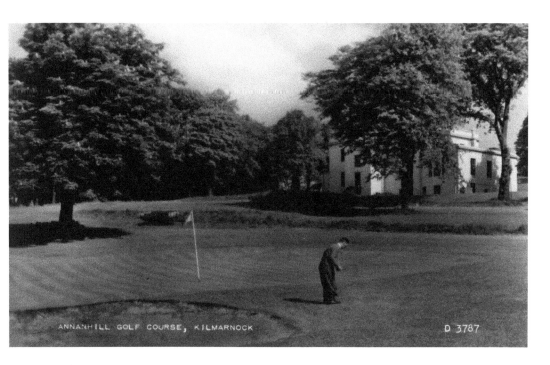

ANNANHILL GOLF COURSE, KILMARNOCK D 3787

Time for Sport

Golf is said to have been invented in Scotland and has been important to Ayrshire for centuries. Kilmarnock has several courses within easy reach, including Annanhill Golf Course, which was opened in 1957 in the grounds of Annanhill House. Curling is also an ancient Scottish sport. It was played in Kilmarnock as early as 1644. The winter of 1740 was severe. Dams were created in the streets around Cross and the area was flooded so that the water would freeze and create an ice rink. This image from around 1904 is thought to be a match between Stewarton Heather Curling Club and Fenwick.

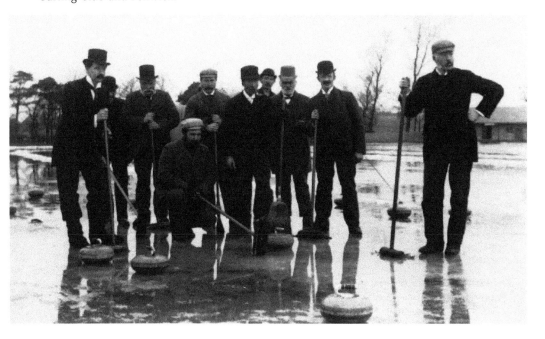

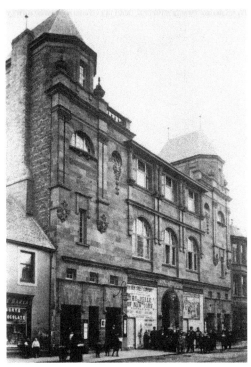

On the Stage

The King's Theatre was opened in Titchfield Street in 1904. One of the earliest performers here is thought to have been a young Stan Jefferson, who later went to the USA and changed his name to Stan Laurel. Another well-known player here was Molly Lindsay, also known as Mary McVie, a Kilmarnock born actress. The building later became a cinema.

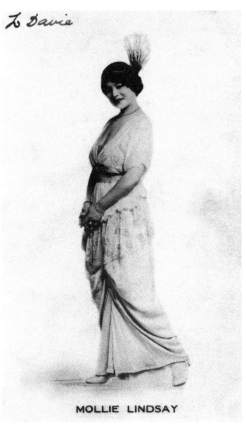

MOLLIE LINDSAY

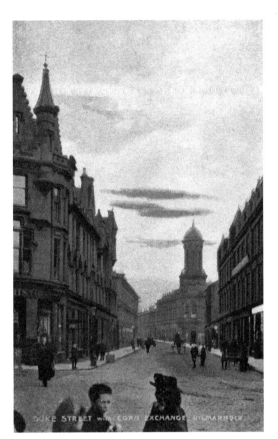

DUKE STREET with CORN EXCHANGE KILMARNOCK

Theatres

The Palace Theatre (above) was opened in 1903. Today, the theatre is in the care of Kilmarnock Leisure Trust and continues to be used for public performances. The Empire Theatre was opened in Titchfield Street in 1913 and was next to the King's Theatre. The Empire later became a cinema. The building was destroyed by fire in 1965.

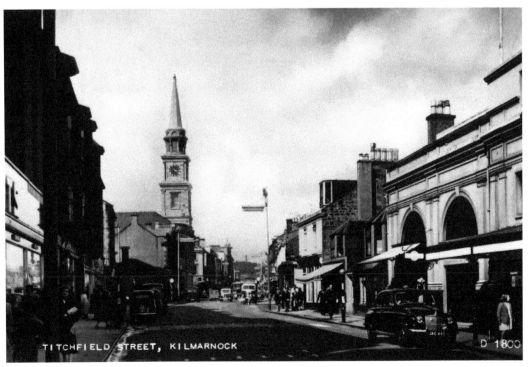

TITCHFIELD STREET, KILMARNOCK D 1800

The Weather

Nothing affects outdoor sports and leisure events like the weather. From time to time pictures of severe weather, such as snow, is used by postcard producers. The picture above is of the Kay Park. The fog picture is a bit unusual. The original picture was taken at Kilmarnock railway station, but the artwork and artist, Gemma Dusk, are both fictional. The postcard was specially produced to promote the book *The Dandelion in the Glass* by Mandy Stafford.

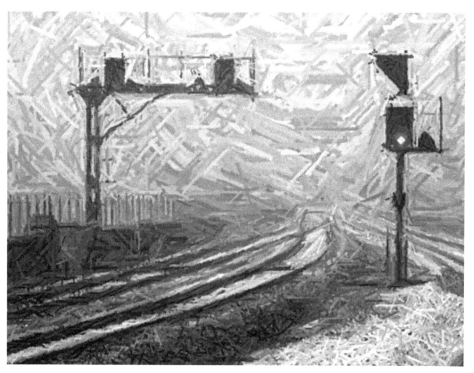

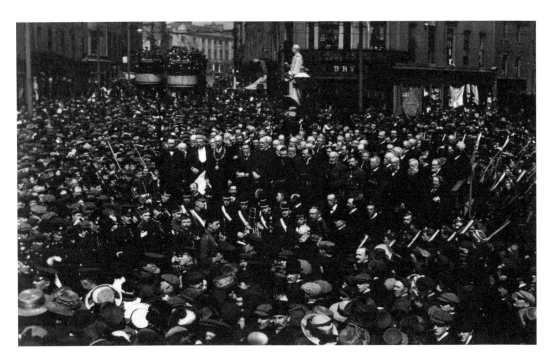

Any Excuse for a Party

We all love parties and sometimes we have a national party. Before the advent of social media, television or even radio, events of the magnitude of the official announcement of a new monarch attracted huge crowds. Above, the royal proclamation of George V in 1910. Below, the town decorated for the coronation of George VI in 1937.

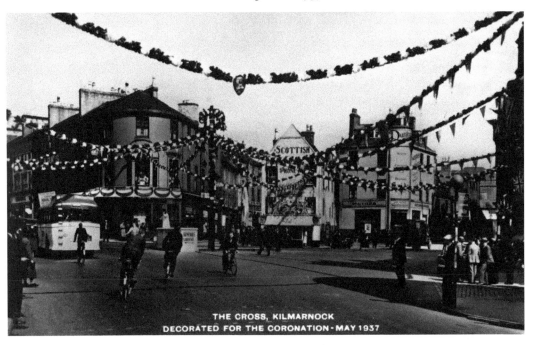

THE CROSS, KILMARNOCK
DECORATED FOR THE CORONATION · MAY 1937

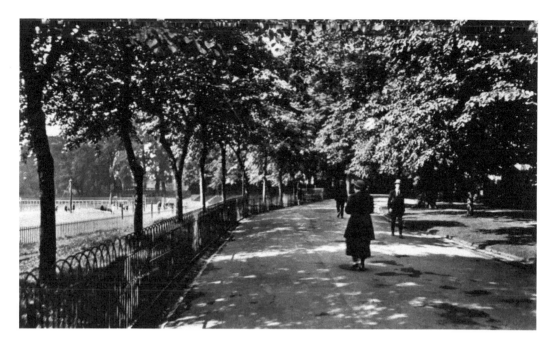

The Vanishing Lady

Both images are from the same negative taken in the Howard Park in 1924. But where has the lady gone? Was she ever there in the first place? Has she nipped off to visit her portrait at Hogwarts School? There is a simple explanation ... can you work it out?

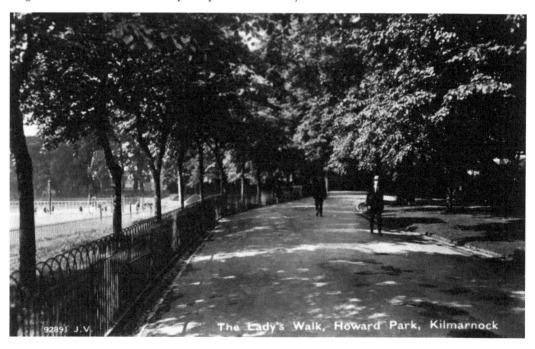

The Lady's Walk, Howard Park, Kilmarnock